AMY BLAKEMORE

AMY BLAKEMORE Photographs 1988–2008

Alison de Lima Greene
with Anne Wilkes Tucker,
Chrissie Iles, and
Marisa C. Sánchez

The Museum of Fine Arts, Houston
Distributed by Yale University Press, New Haven and London

This catalogue was published to coincide with the exhibition *Amy Blakemore: Photographs 1988–2008* at the Museum of Fine Arts, Houston, May 9–September 13, 2009.

Publications Director: Diane Lovejoy
Editorial Manager: Heather Brand
Designed by Emily Hoops Sanders
Reproduction photographer: Thomas R. DuBrock
Printed in the United States of America

Distributed by Yale University Press,
New Haven and London
www.yalebooks.com

Front cover illustration: Amy Blakemore, *Jill in Woods,* 2005, chromogenic photograph, 19 x 19 inches (48.3 x 48.3 cm)

Back cover illustration: Amy Blakemore, *Swing,* 1992, gelatin silver photograph, 15 x 15 inches (38.1 x 38.1 cm)

Library of Congress Cataloging-in-Publication Data

Blakemore, Amy, 1958–
 Amy Blakemore : photographs 1988–2008 / Alison de Lima Greene with Anne Wilkes Tucker, Chrissie Iles, and Marisa C. Sánchez.
 p. cm.
 Includes bibliographical references.
 Summary: "Presents a twenty-year survey of the black-and-white and color photographs of Amy Blakemore, taken with a Diana camera, accompanied by four essays and an interview with the artist"—Provided by publisher.
 ISBN 978-0-300-14699-8 (pbk. : alk. paper)
 1. Photography, Artistic. 2. Blakemore, Amy, 1958–
I. Greene, Alison de Lima. II. Title. III. Title: Photographs 1988–2008.
 TR655.B55 2009
 770.92—dc22
 2008051615

This book is dedicated in memory of Robert T. and Mary Tippin Blakemore
—Amy Blakemore, 2009

SPONSORS

Amy Blakemore: Photographs 1988–2008
has been organized by the Museum of Fine
Arts, Houston.

Major sponsorship is provided by:

Mr. and Mrs. Michael C. Linn

**Generous funding is provided by
the Friends of Amy Blakemore:**

The Bequest of Edward B. Mayo

Leslie and Jack Blanton, Jr.

Leslie and Brad Bucher

Sara Paschall Dodd-Spickelmier
 and Keith Spickelmier

Dillon Kyle and Sam Lasseter

Carey C. Shuart

Mary and George Hawkins

Nancy Powell Moore

The Alice Kleberg Reynolds Foundation

Dr. and Mrs. Byron York

Phyllis and George Finley

Charlotte and Bill Ford

Allyson Hancock Kinzel and Jason B. Kinzel

Karen McClure and Jeff Post

Iman Saqr

Denby Auble and Kerry Inman

Cynthia Morgan Batmanis

Deborah Bay and Edgar Browning

Mary Kay and Bob Casey

Keith Forman and Mary Morton

Lynn Goode

Mr. and Mrs. Stephen J. Gross

Kathy Oliver

Christopher E. Vroom

Jill Whitten and Robert Proctor

Clinton T. Willour

Additional support is provided by:

Rebecca A. Bratton

David N. Britton

Shelley Calton

Susanne Devich and Lee Bergman

Anne Ribble

Edie Stavinoha

Betsy Haas

Mary Murrey and Michael Ittmann

Tom Oldham

Valerie Owhadi

CONTENTS

FOREWORD

In the autumn of 1982 the Museum of Fine Arts, Houston (MFAH), inaugurated the Core Program, inviting artists for one- and two-year residencies at the museum's Glassell School of Art. Conceived as a laboratory for research and experimentation by Allan Hacklin, then director of the school, and Rachel Hecker, assistant director, the Core Program established an open and critical environment that encouraged young artists to break new ground and refine their practice. This past year saw the twenty-fifth anniversary of the Core Program, prompting the MFAH to consider how this initiative has played a role in the larger art world. *Amy Blakemore: Photographs 1988–2008* is one of several projects the museum has undertaken to highlight this important landmark in our institutional history.

Arriving in 1985, Amy Blakemore was among the Core Program's early residents, and she has recalled: "I think I learned more in those two years than at any other time in my life. It certainly sent me in a direction…that I never would have imagined or considered." Much as this residency gave direction to Blakemore, she has in turn given direction to Houston. Among the Core fellows who elected to remain in this city after their residency was complete, Blakemore is one of those who quietly has made an enormous difference. She joined the Glassell School faculty in 1986, and over the past two decades not only has she steered the school's expanding commitment to teaching photography, she has also emerged as an important mentor, bringing to her classes the rigorous eye and creative intuition that informs all her work. Independent of the MFAH, she has also established a career that has brought her both national and international recognition.

One way to measure the impact Blakemore has had on our community is the wide-ranging support this exhibition and catalogue have attracted, and major donors have come together as the "Friends of Amy Blakemore" to make this project possible. Their names appear on the sponsors page, and I would like to salute them for their leadership role in this endeavor. Additionally, many former students and friends have made contributions as well, and they too are cited with gratitude.

I would also like to acknowledge the museum's supporters who have made it possible for the MFAH to assemble a permanent document of Blakemore's

achievement. Thanks must go first to Clinton T. Willour, who donated *Three Girls* (see page 32) to the museum in 1989, launching our commitment to collecting the artist's work. In subsequent years Clint has made other key donations, including prints of *Plaza, Apples*, and *Harlow* (see pages 39, 42, and 43). I am also grateful to Christopher E. Vroom for his gift of three of Blakemore's most evocative images (see pages 56, 57, and 59). Other important gifts have come to Houston from the artist herself, from Mrs. Clare A. Glassell, Inman Gallery, Steven J. Snook, Will Michels, from the board and staff of DiverseWorks in memory of Chris Kalil, and from the MFAH staff.

The thirty-six photographs gathered in this exhibition are not intended to serve as a full retrospective. Alison de Lima Greene, the MFAH's curator of contemporary art and special projects, has assembled a selective survey, outlining rather than detailing the trajectory of Blakemore's development. Her careful research and the essay published here match the artist's exacting attention to detail. I'd like to thank her, as well as the catalogue's other authors, Anne Wilkes Tucker, Chrissie Iles, and Marisa C. Sánchez, for their astute appraisals of Blakemore's work.

From its inception, photography has sought to arrest motion, to portray the transitory, to distill light in a single decisive moment. Making a distinctive contribution to this rich history, Blakemore demonstrates a remarkably offhanded ability to sidle up to her subjects, capturing intimate moments and fleeting instances of illumination. From her first documentary essays to her most recent portraits and landscapes, she reveals the marvelous in the everyday, the transcendent in the ordinary.

Peter C. Marzio
Director
The Museum of Fine Arts, Houston

ACKNOWLEDGMENTS

Many colleagues at the Museum of Fine Arts, Houston, have worked together to make *Amy Blakemore: Photographs 1988–2008* a success. This exhibition first came about through conversations with Peter C. Marzio, director of the MFAH, and Joseph Havel, director of the museum's Glassell School of Art. I am deeply grateful for their unwavering commitment to Amy Blakemore's work and for their wise encouragement as the exhibition developed. Also at the MFAH, Anne Wilkes Tucker has been a champion of this project from its beginning, and her essay builds on many years of working with Blakemore; additional thanks are due to Chrissie Iles at the Whitney Museum of American Art and Marisa C. Sánchez at the Seattle Art Museum, whose thoughtful contributions to this publication bring new perspectives to Blakemore's ongoing project.

Profound thanks are also due to other MFAH staff members as well, starting with Diane Lovejoy, publications director, Heather Brand, editorial manager, and Emily Hoops Sanders, senior graphic designer; as always, their vision for what a museum catalogue can be is inspiring. Marty Stein, photographic services manager, Will Michels and Matt Lawson, digital imaging specialists, and Thomas R. DuBrock,

photographer, are responsible for the reproductions seen in this catalogue. Will Michels was also a vital participant in many early conversations about the exhibition.

Credit must also go to Gwendolyn H. Goffe, associate director of investment and finance, Amy Purvis, associate director of development, Valerie Greiner, director of special gifts, and Kathleen Jameson, assistant director, programming and grants coordinator for capital projects. The physical coordination of the exhibition has been undertaken by Karen Vetter, chief curatorial administrator, Julie Bakke, registrar, and exhibition registrars Kathleen Crain, John Obsta, and Heather Schweikhardt; Brooke Barclay, matting and framing manager, and Daniel Estrada and Brandon Foster, framing technicians; Bill Cochrane, exhibition designer, and Michael Kennaugh, senior preparator. Thanks are also due to Margaret Culbertson, library director, and Jon Evans, associate librarian; Mary Haus, director of marketing and communications, and Dana Mattice, associate publicist; Victoria Ramirez, the W. T. and Louise J. Moran Education Director, and Margaret Mims, associate education director. Elliott Zooey Martin, curatorial assistant, deserves sincere applause

for her efforts, while Miranda Warren, administrative assistant, and Lisa Danaczko, summer intern, were also unstinting in their support.

Kerry Inman began working with Blakemore in 1994; along with the staff of Inman Gallery—Patrick Reynolds, Will Henry, and Maria Merril—she has been an ideal partner in this endeavor, as has Amy Blakemore. Amy opened her files and archives without reserve and gave many hours to interviews and follow-up questions. Additionally, she created new prints of all works featured in this exhibition with her typical care and masterful touch. It is a true pleasure to present Amy Blakemore's work of the past two decades and a privilege to count her a colleague and a friend.

Alison de Lima Greene
Curator, Contemporary Art and Special Projects
The Museum of Fine Arts, Houston

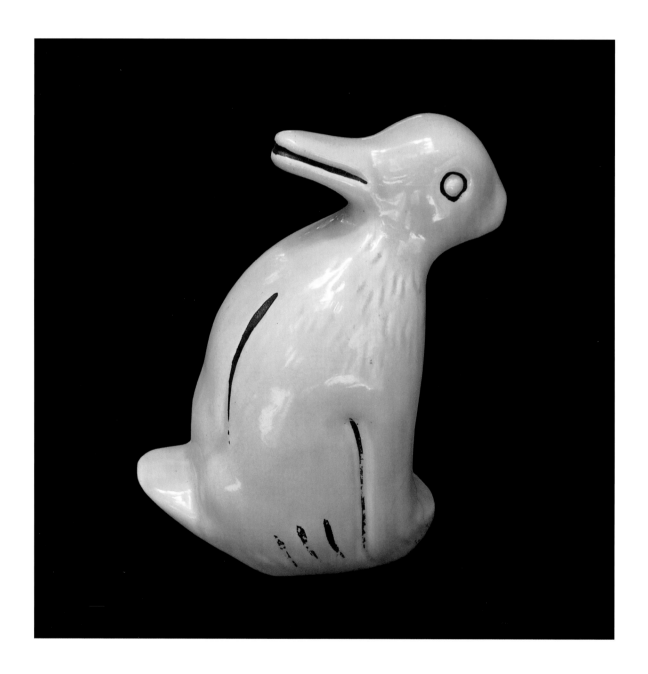

Fig. 1. "Rabbit or Duck" vase, no date, 6 ¼ inches (15.9 cm) high.

AMY BLAKEMORE PHOTOGRAPHS

Alison de Lima Greene

Rabbit or Duck

In 1956 E. H. Gombrich opened his Mellon Lectures at the National Gallery of Art with an ambiguous illustration that could be read as either the head of a rabbit or a duck.[1] He pointed out that this drawing had originally appeared in the pages of *Die Fliegende Blätter* as a playful visual pun.[2] He also noted that it appeared in late-nineteenth-century psychology texts, as well as in Ludwig Wittgenstein's recently published *Philosophical Investigations*.[3] What interested Gombrich was the subjective conundrum inherent in our reading of the image, whether in the context of a popular magazine or a philosophical tract. He commented: "We can see the picture as either a rabbit or a duck. It is easy to discover both readings. It is less easy to describe what happens when we switch from one interpretation to the other.... Illusion, we will find, is hard to describe or analyze, for though we may be intellectually aware of the fact that any given experience *must* be an illusion, we cannot, strictly speaking, watch ourselves having an illusion."[4]

Some thirty years later, two American artists embraced the "rabbit or duck" icon. Jasper Johns traced Wittgenstein's version of the illustration in drawings as early as 1984, and incorporated it into his densely autobiographical painting *Spring,* 1986 (Robert and Jane Meyerhoff Collection). For Johns, well-schooled in Duchampian conceptual play, the "rabbit or duck" silhouette pointed to his long-held interest in visual and thematic ambiguity. Along with concealed profiles, camouflaged imagery, and other fragmented references, it became a key element in Johns's increasingly personal catalogue, yet another signifier revealing the artist's fascination with the impossibility of fixed meaning.

Amy Blakemore came to the "rabbit or duck" figure by a very different route. Visiting a thrift store in the Oak Cliff suburb of Dallas with friends in 1986, she discovered a small green "rabbit or duck" ceramic vase (fig. 1), and she purchased it for three dollars: "I had never seen something like this before, and I immediately fell in love with it."[5] The vase quickly became one of her most cherished items, and while Blakemore has refrained from incorporating it into her photographs, the combination of the vernacular with perceptual duality could easily stand as a key to understanding Blakemore's work. Indeed, when curators Chrissie Iles and Philippe Vergne asked

the 2006 Whitney Biennial artists, "If you could crystallize the last two years in one image, one word, one piece of text, one object, what would it be?" she responded with this vase.[6]

I started taking photos when I was in the fourth grade.

When Amy Blakemore was coming of age in the mid-1970s, photography was still very much a stepchild in the field of contemporary art. Few museums had established departments dedicated to photography, and even such vanguard institutions as the Museum of Modern Art were only just beginning to investigate the role color photography might assume.[7] Blakemore's native Tulsa landscape offered few opportunities to encounter new work (despite Larry Clark's recent portrait of the city's underground drug culture), and as Blakemore recalls, early visits to the Philbrook and the Gilcrease museums took second place to excursions to the Woolaroc nature center.[8] Her first camera was a Kodak Instamatic, and in seventh grade she acquired a Polaroid Swinger, toys for many children of her generation. For Blakemore, however, they sparked an

interest that she pursued with increasing dedication. Several years later, she transferred to Booker T. Washington High (BTW), then one of the city's most progressive schools, which offered not only classes in photography, but also a well-equipped darkroom that rivaled the local university. "I wanted to go to BTW regardless, but the fact that photography was offered cinched it for me," Blakemore has recalled. "I worked at Antoine's deli for $1.60 an hour and bought a used Mamiya/Sekor 500 DTL for $65."

In 1976, Blakemore entered Drury College (now Drury University) in Springfield, Missouri, where she majored in sociology and psychology. In the course of her studies, Blakemore became fascinated with the Thematic Apperception Test (TAT) and its illustrations, developed by the American psychologists Henry A. Murray and Christina D. Morgan in the 1930s.[9] During her last year, she was drawn to Drury's loosely structured art classes, which, through the liberal policies of such teachers as Tom Parker, allowed her to pursue photography whether she was enrolled in painting, sculpture, or drawing. In addition to Parker, Michael Dickey, the first photographer to join the faculty, proved to be a generous mentor. Off

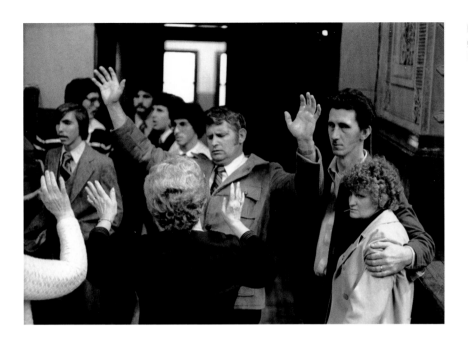

Fig. 2. Amy Blakemore, *Untitled*, 1979, gelatin silver photograph, 10 ⅝ x 13 ¾ inches (27.2 x 35.1 cm).

campus, Robert E. Smith, a self-taught artist, was equally inspiring. Dickey encouraged Blakemore to act independently, without reference to the work of other photographers, while Smith introduced Blakemore to nontraditional means of art-making, as he embraced found materials, mundane and fantastic subjects, and written narrative.

One of the skills Blakemore refined during her college years was an ability to insinuate herself into lives outside of academic precincts. Her talent for approaching subjects who might otherwise be on guard is evident in an untitled 1979 photograph that Blakemore has identified as a key statement from her student years (fig. 2). Taken at an evening prayer meeting, the image is both detached and curiously intimate, capturing the moment when several members of the congregation are raising their hands in worship as others join in prayer. Only one couple eyes the camera, perhaps uneasy with this outside witness.[10]

Blakemore ultimately earned two baccalaureate degrees at Drury, one in sociology and psychology, the second in art. She balanced studio classes with a full-time shift at the city hospital's psychiatric unit, where she worked from midnight to dawn as a counselor. In 1982 she enrolled in the master's program at the University of Texas at Austin (UT). At UT, the photography department was largely independent of the art department, and Blakemore has recalled, "We didn't say we were artists in graduate school.... We were documentarians." However, the documentary tradition at Austin was a rich one,

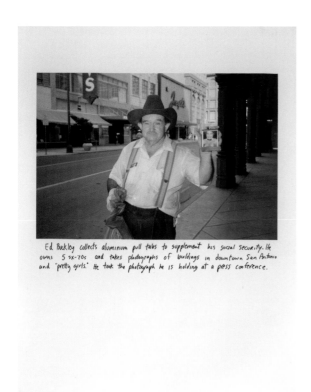

Ed Buckley collects aluminum pull tabs to supplement his social security. He owns 5 sx-70s and takes photographs of buildings in downtown San Antonio and 'pretty girls.' He took the photograph he is holding at a press conference.

Fig. 3. Amy Blakemore, *Ed Buckley, San Antonio*, 1985, chromogenic photograph with inscribed text, 14 x 11 inches (35.6 x 27.9 cm).

shaped by Russell Lee and Garry Winogrand.[11] Blakemore studied with Mark Goodman and Ellen Wallenstein, and while sitting in on undergraduate classes, she encountered the larger history of photography: "My favorites were Diane Arbus and August Sander. I was crazy about them. I still get kind of giddy when I see Arbus's pictures after not seeing them for a while, Sander's, too."

Blakemore undertook two documentary projects during her second and third years at UT. One echoed Robert E. Smith's hand-drawn narratives, portraying individuals whom Blakemore had met on trips outside of Austin.[12] The first of these story-pictures

were in black-and-white, but Blakemore soon switched to color (a process that went against the grain of much of UT's program). Blakemore found her subjects on the streets of San Antonio and in mom-and-pop stores: "They were so interesting to me, and I'd write it all down." On the lower margin of these portraits, Blakemore described each encounter: "Ed Buckley collects aluminum pull tabs to supplement his social security. He owns 5 SX-70s and takes photographs of buildings in downtown San Antonio and 'pretty girls.' He took the photograph he is holding at a press conference." (fig. 3) The second series recorded the last days of Austin's Alamo Hotel (formerly grand, then an SRO), which was on the verge of being torn down. Initially planning an essay on the hotel's architecture, Blakemore turned her camera instead on its residents, perched on their beds or standing in doorways. Taken with a medium-format camera, the series is remarkably vivid, both in Blakemore's close-up engagement with her subjects, and in the high-key palette of many of the pictures.

One last series came out of Blakemore's graduate school years, pictures of her uncle Jim's farm and a handful of family portraits, created with a Diana

camera. Introduced to the Diana by Wallenstein, Blakemore considered these the least resolved examples of her graduate work. Nonetheless, at the advice of Rachel Hecker, then assistant director of the Glassell School of Art at the Museum of Fine Arts, Houston (MFAH), she included her Diana pictures in her application to the Glassell's Core Program.[13] On learning that it was the Diana pictures that earned her acceptance into the residency program, rather than her documentary work, Blakemore was both horrified and intrigued.

I saw the Core Program as an opportunity.

Blakemore moved to Houston in 1985, entering the Core Program in the fall, along with fifteen other artists-in-residence. Then in its fourth year under the guidance of the school's director, Allan Hacklin, the program was loosely modeled on the laboratory atmosphere of CalArts (California Institute of the Arts); postgraduate artists were offered studio space and twenty-four-hour access to the school's facilities, a modest stipend, and critical feedback from visiting artists, writers, and curators. Among the visitors to the Core studios during Blakemore's two-year tenure were Lynda Benglis, Ross Bleckner, John Caldwell, Jan Groover, Roni Horn, Duane Michals, Peter Schjeldahl, and Gary Stephan. But more important than the visitors was the interchange among peers, and Blakemore formed vital friendships with other Core artists, including Julia Kunin, Michael Miller, and Maria Rojas, and later residents Robert Ruello, Mattie van der Worm, Isabel Farnsworth, and Adam Lowenbein. For Blakemore, the Core Program was like being confronted with a *tabula rasa:* "Looking back I can't believe how very little I knew when I started the program. I knew absolutely nothing about being an artist, the art world, or a possible place for me in it. … I think I learned more in those two years than any other time in my life."[14]

One of the crucial aspects of the Core Program was the permission it granted its residents to work outside of the categories imposed by most graduate schools. Michael Miller has described the program as "an exceptional venue for exorcising the ghosts of my education,"[15] and Kristin Musgnug recalls "one of the best things about [the Core Program] was simply the gift of time, which allowed me to empty my mind of all I had been taught in school, and

flounder around until I found my own direction."[16] Blakemore used her two years in the Core Program to investigate the potential of working with the Diana camera, relishing the degree of spontaneity it offered: "Those big cameras I was using in grad school had become a kind of barrier—alienating people—and took longer to focus. With the Diana it's just 'click!' And when people see you with that camera, they don't worry about it." She also grew to appreciate the fact that the Diana was considered an amateur's tool, one that no professional photographer would employ.[17] By the end of her two years in the program, she had returned to working in black-and-white, and the Diana had become her camera of choice. Nonetheless, few of the photographs she had made during her Core tenure satisfied her, and Blakemore debated whether to return to graduate school to take a degree in social work. Ultimately she opted to remain in Houston; she joined the Glassell School faculty and made a commitment to continue taking photographs.

Houston in the mid-1980s was wide open to young artists. Although the oil glut of the early years of the decade had decimated the city's energy market, low real-estate values made living in Houston relatively cheap and easy. In addition to the Core Program, the University of Houston's vibrant studio department also drew emerging artists to the city. Commercial galleries, university galleries, and alternative spaces provided a broad range of exhibition opportunities. These years also saw an increasing audience for photography as the recently established FotoFest organized its first biennials in 1986 and 1988. A month-long series of exhibitions, conferences, and portfolio-review sessions, FotoFest was a citywide phenomenon, embracing both traditional forms of photography and such performance-based projects as Nan Goldin's *Ballad of Sexual Dependency* (seen at Rice University in 1988). At the same time, curator Anne Wilkes Tucker was mounting significant exhibitions at the MFAH. In 1986 she organized the groundbreaking *Robert Frank: New York to Nova Scotia* (a project that Blakemore recalls as "thrilling"), and two years later she brought a Henri Cartier-Bresson retrospective to Houston. Across the street, the Contemporary Arts Museum Houston (CAMH) mounted a survey of Robert Rauschenberg photographs in 1986, and introduced the photo-based work of Robert Longo (1986), Gretchen Bender (1988), and Bill Viola (1988).

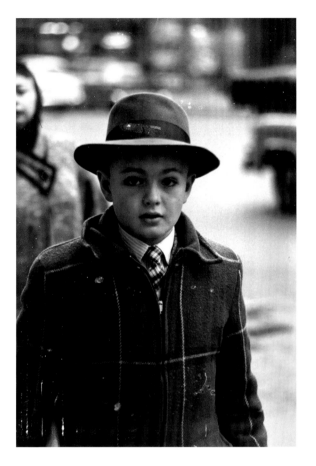

The word inspired *has more meaning to me than* influence.

Within a year of completing the Core Program, Blakemore began a series of photographs that would mark the start of her mature career. Over the subsequent decade, she built an increasingly rich body of work, assimilating past interests, and filtering them through the meshes of memory and decisions made in the darkroom. And as her command of the Diana format evolved, Blakemore deliberately eschewed the self-reflective strategies embraced by many of her contemporaries. Some of her compositions assume a remarkably abstract formality rooted in the history of Modernism; others seem to respond to specific precedents. When asked about possible influences, Blakemore denies setting up her shots to achieve these effects, and only later in the darkroom does she discover the pictures she chooses to print. Thus it is the process of selection, not appropriation, that allows Blakemore to sample (at times intuitively) certain artists whose work she finds inspiring.

Typically, much of her work was created outside of Houston, as Blakemore found freedom and insight in leaving teaching duties and daily routines behind. Starting with *Three Girls* (see page 32), the first of these series was made during visits to New York, in Brooklyn's Roebling Park, then a largely Hassidic community. Blakemore uses her documentary skills to close in on her subjects, who return the camera's stare unblinkingly. It is tempting to compare these images with Arbus's street photographs, and such works as *Boy in a Man's Hat, NYC,* 1956, offer a provocative precedent (fig. 4). While both artists address young children with little sentimentality, allowing a degree of background incident to suggest

the transitory nature of the immediate surroundings, Blakemore grants her subjects a degree of vulnerability not found in Arbus, provoking a sense of empathy on the part of the viewer. Additionally, the square format of the Diana print creates a more indeterminate frame, unlike the tightly cropped portrait window adopted in this instance by Arbus. Finally, the uncertain depth of field introduced by the Diana evokes a temporal or perceptual slippage, rather than Arbus's insistent present.[18]

Blakemore pushed in new directions in a second series of works from the summer of 1992. Earlier that year, she received a travel grant from the Dallas Museum of Art that allowed her to join a pilgrimage to Lourdes, a destination made sacred by the visions of Bernadette Soubirous in the mid-nineteenth century. She also visited Santiago and Fatima. Much as she had slipped into a prayer meeting in 1979, Blakemore turned her camera on the convents, reliquary shops, and plazas of these cities, seeking meaning at the site of religious faith. She brings an informed eye to this series, and such images as *Cloistered Convent* (see page 36) resonate with the work of Cartier-Bresson (fig. 5). However, Blakemore's project also remains distinct from such historical precedents. Whereas Cartier-Bresson famously sought to capture the "decisive moment," Blakemore's views suggest the impossibility of such decisiveness. Prowling the precincts of faith and healing, Blakemore instead finds emptiness and vertigo.[19]

It was during a subsequent pilgrimage tour that Blakemore returned to working in color. *Cod,* 1995, taken in the seaside town of Nazaré, Portugal, was the first color image she chose to print in almost a decade (see page 44). Unlike her first pilgrimage series, which focused on the insubstantial, *Cod* signals a new compositional strategy, a move to almost pure abstraction combined with an adamant insistence on the material subject. This strategy is found again in *Apples,* 1995, *Sea,* 1997, and *Shoes,* 1998 (see pages 42, 46, and 45). The abandonment of the horizontal vista and the embrace of overall compositions have a strong history in early Modernist photography, for example Alfred Stieglitz's *Equivalents* (1925–31). Blakemore's landscapes also find analogies in the work of painters who have turned to photography, such the luxuriantly saturated photographs of Cy Twombly (1990–93), or in the conceptually based approaches of Roni Horn (for example, Horn's ongoing chronicle of

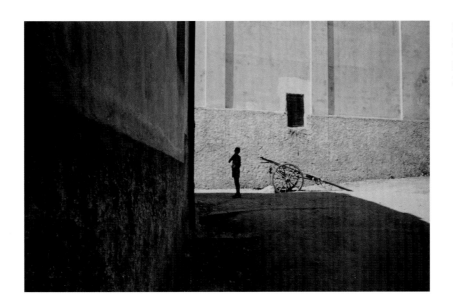

Fig. 5. Henri Cartier-Bresson, *Salerno*, 1933, gelatin silver photograph, $7^3/_4$ x $11^7/_8$ inches (19.7 x 30 cm), the Museum of Fine Arts, Houston, the Manfred Heiting Collection, 2002.764.

Iceland, begun in 1990). And elsewhere in this catalogue, Marisa Sánchez successfully compares this work to the seascapes of Vija Celmins. However, Blakemore's overall abstractions also have the quality of the filmic mise-en-scène, the establishing shot that both sets up and punctuates the larger narrative arc.[20] Much as David Lynch uses the lawn in front of the Beaumont household to predict scenes to come in *Blue Velvet,* 1986, Blakemore finds evidence of decay, neglect, and beauty in the landscape, which can shift from the tranquil (*Sea*) to the haunting (*Shoes*).

A similarly cinematic sensibility animates many of Blakemore's portraits. Turning her camera on a circle of immediate friends and family, Blakemore seeks out fleeting moments of natural illumination and unguarded connection. As *Adam,* 1991 (see page 40), demonstrates, she adopted this strategy while still working in black-and-white, using a shaft of light and the sitter's direct gaze to establish mood. However, these qualities become even more evident in her color portraits, and bathed in the sun's glow, *Steph,* 1995, and *Harlow,* 1998 (see pages 41 and 43), assume the aura of movie stars. Each seems caught in an instant within a larger drama, tempting viewers to create stories around these captured images.[21] Of course, Blakemore is not alone in exploiting the language of cinema, and Cindy Sherman's *Untitled Film Stills* (1977–80) can be cited as an important precedent. Yet Blakemore's pictures, saturated and intimate, find a closer parallel in Nan Goldin's diaristic chronicles. Goldin's *Vivienne in the Green Dress, NYC,* 1980 (fig. 6), offers a particularly compelling contrast to Blakemore's *Harlow*. Both subjects are tightly framed, both have the informality of snapshots, both are clad in vivid colors, both are sexually charged.[22]

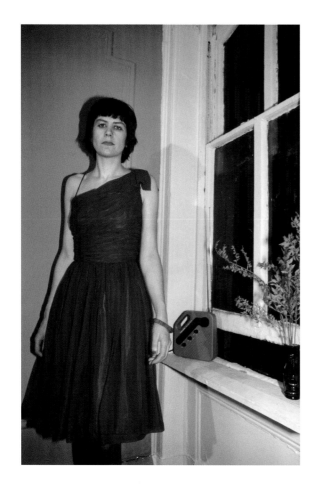

Fig. 6. Nan Goldin, *Vivienne in the Green Dress, NYC*, 1980, silver dye bleach photograph, 23 ³⁄₈ x 15 ⁷⁄₈ (59.4 x 40.2 cm), the Museum of Fine Arts, Houston, gift of Michael Zilkha and Diego Cortez, 2007.726.

However, there are important differences as well. *Vivienne* is very much a night picture, frozen before a bounce flash. *Harlow* is not only sunlit, but also in nature, the figure almost wedded to the earth below her. Vivienne stands before the camera, pushed into a corner and withdrawn; Harlow reclines, coming into the frame from above, the figure cropped and abstracted, but also expansive and generous.

A final defining inspiration in Blakemore's maturing body of work is the example of William Eggleston, an artist she has confessed to admiring profoundly. Many of her images of the late 1990s and early 2000s echo segments of the vernacular landscape Eggleston mapped out in his Mississippi and Tennessee photographs. Blakemore also appreciates the absurd shift in scale found in such works as *Memphis,* c. 1969, a seemingly outsized tricycle enshrined on the cover of *William Eggleston's Guide.*[23] But perhaps the aspect of Eggleston's work that resonates most importantly with her is his ability to seize on the ordinary, and a particularly telling comparison can be found between Eggleston's *The Red Ceiling (Greenwood, Mississippi),* 1973 (fig. 7), and Blakemore's *Flag,* 1999 (see page 53). Both photographs frame domestic details: in Eggleston's case an amateurly wired ceiling fixture in a blood-red room, and in Blakemore's case, a flag or emblem created out of plastic carnations and ferns hanging on a white wall. Both images are shot looking up at a corner, and both are pared down to an almost minimal palette. However, where Eggleston relishes the up-close saturation of his image, Blakemore uses the grainy texture of her print to distance the scene from our gaze. And where Eggleston specifically locates his photograph, Blakemore gives us no further information in the title,

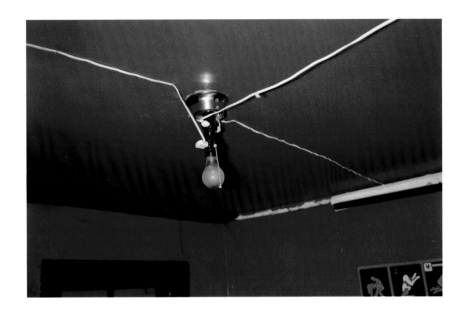

Fig. 7. William Eggleston, *The Red Ceiling (Greenwood, Mississippi)*, 1973, dye transfer photograph, 11 7/8 x 18 3/8 inches (30 x 46.7 cm), the Musuem of Fine Arts, Houston, gift of Caroline Huber and Walter Hopps in honor of Anne Wilkes Tucker, 99.563.

although the issue of nationhood was particularly pertinent to where *Flag* was made.[24] For Blakemore, the most important thing about photographing *Flag* was the opportunity to fix in her memory a wonderful and strange artifact that had captured her imagination.

Photographing makes me remember things.

In December 1999, Blakemore returned to Tulsa. Intending to visit family for the holidays, she discovered on arrival that her father was dying. In the days that followed, she paid tribute to her father and family in a powerful series of works that are uncompromising in their beauty, austerity, and sorrow (see pages 55–58). She returned again to the twinned themes of mourning and parental love with *Dog in Snow,* 2004, and *Mary,* 2008 (see pages 59 and 54).

Addressed eloquently by both Sánchez and Chrissie Iles elsewhere in this publication, these pictures mark a critical turning point in Blakemore's career. While earlier works also probed memory and immediate experience, the Tulsa photographs introduce a different temporality, one that accepts the finality of death. And while earlier photographs might induce a sense of nostalgia in the viewer, these images are absolute and insistent in bearing witness to what might otherwise be an unbearable present.

The role that time and memory play in Blakemore's work has been discussed by a number of writers. In 1999 Anne Wilkes Tucker observed: "Photography is generally a medium that deals best with the present. Blakemore resists this dictum. She is interested in the relationship of objects to memory and imagination.... Between revelation and obstruction is a

space that allows the viewer to [in Blakemore's words] 'complete the picture though her or his own experience.' Blakemore allows just enough specificity to initiate and direct our individual and personal responses."[25] In the same publication, Susie Kalil added, "[Blakemore's] unabashedly contemplative photographs force us to look back to where we have come from, if only to surmise where we may be going."[26] More recently, Michelle White has written: "The emotional power of the imagery is firmly located in Blakemore's remarkable and almost cerebral demonstration of how we remember. Read as incongruent strings of intimate thoughts, [the work] becomes a beautifully deliberate presentation of the inability to control when and what images from the past flash in our mind, and always unexpectedly seep into our thoughts."[27]

Other artists have found that the Diana camera's indecisive depth of field captures the elusive nature of fragmentary emotions and memory. Nancy Rexroth, one of the first fine-art photographers to embrace the Diana camera, has noted: "The Diana's made for feelings. Diana images are often something you might see faintly in the background of a photograph.... Sometimes, I feel I could step over the edge of a frame and walk backwards into this unknown region. Then I would keep right on walking."[28] Of her *Iowa* photographs, Rexroth comments further that they were created to record "things remembered in that instant before sleep."[29] Rexroth's *Nothing in Particular,* taken in 1973 (fig. 8), distills the intentional ambiguity of this series. A landscape stripped down to its formal essence, the image is as intangible as a faded snapshot discovered in an anonymous family album. In contrast, Blakemore never pushes her work to such a degree of disassociation: her work ultimately is always about *somewhere* in particular. Indeed, Blakemore sees the act of photography as a means of collecting: "Instead of picking up stuff, I leave with a flat, squared-off record of things and people in space."[30]

Blakemore's engagement with memory and experience is discussed further in the other essays contained in this catalogue, and in statements by the artist. However, in the larger context of Blakemore's career, considered here, it is of critical importance to note the role that recognition, as well as memory, plays in the reception of Blakemore's work. One of the reasons many viewers respond so intensely to

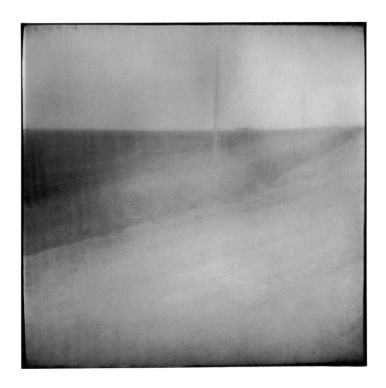

Fig. 8. Nancy Louise Rexroth, *Nothing in Particular*, 1973, gelatin silver photograph, 3 ⅞ x 4 inches (10 x 10.2 cm), the Museum of Fine Arts, Houston, the Allan Chasanoff Photographic Collection, 91.1031.

photographs like *Dad* (see page 56) is that it is an already familiar visual trope, whether anchored in personal experience, or mirrored in the larger history of art, film, and photography. Blakemore is keenly aware of the psychological dimension of these photographs, and in the possibility of leaving the interpretations they imply open. In a recent statement, she commented on her early fascination with the TAT illustrations: "I was most interested in the odd images and projective nature of the testing procedure. After viewing the image cards, the subjects are asked to provide a narrative: what does this bring up for them, what, or who are the characters and what are they thinking or feeling? This is an appealing relationship between viewer and image; however, I am more interested in asking the question than evaluating the response."[31]

This commitment to the unstable narrative ultimately returns to Blakemore's delight in "rabbit or duck" and Gombrich's assertion that "any given experience *must* be an illusion." Many of Blakemore's recent photographs celebrate visual conundrums waiting to be discovered by her camera lens. *Deer and Tepee,* 2005 (see page 60), seems to capture the tilting curve of the earth's surface, held in place by an improbable array of lawn ornaments. *Little Garage,* 2004 (see page 61), appears to have been built to shelter a very small dog rather than a car. *Astoria,* 1998/ 2008 (see page 66), conflates actual architectural

fragments and flora with an impossibly stacked landscape mural. Much as a collector seeks out the marvelous and strange, Blakemore assembles these images into her ever-expanding album.

Look at the light.

Any overview of Amy Blakemore's work must ultimately end with light. Light is the essential agent of photography, and Blakemore manipulates it expertly, from the first click of the shutter to the laborious process of coaxing images from negatives and fixing them on paper. In her early black-and-white photographs, Blakemore uses the Diana's tendency to vignette as a way to capture light at the center of her compositions. In later works, ambient light alternates with startling shafts of illumination, igniting the New Zealand landscape, beaming from New York City windows, or washing over Tulsa fairgrounds (see pages 48–51). In such recent photographs as *Airplane,* 2005 (see page 63), the quality of light is almost ecstatic as Blakemore turns her camera literally toward the sun. It bounces off the windshield of a parked car in *Boston Street,* 2004 (see page 62), or becomes a mysterious, irreal presence in *Monument,* 2005, and *Jill in Woods,* 2005 (see pages 64–65). In *Pam,* 1997/2008 (see page 67), the closing image of this survey, direct sunlight, reflected light, and shadow slice across the composition with the luminescent splendor of a Mark Rothko painting. Blakemore has insisted: "When I take photos it starts with the light, the beautiful light that happens after a storm in the afternoon when the sky is clean. I always notice the light. I once stopped at a student's house to get him to come out to look at the light. Look at the light."

NOTES

1 E. H. Gombrich, "Art and Illusion," The A. W. Mellon Lectures in the Fine Arts, Washington, D.C.: The National Gallery of Art, 1956. Later published as *Art and Illusion: A Study in the Psychology of Pictorial Representation* (New York: Pantheon Books, 1960), 5.

2 *Die Fliegende Blätter* was a popular German humor magazine published in Munich; the "rabbit or duck" image first appeared on its pages in October 1892. The illustration was immediately picked up by *Harper's Monthly* (November 1892), and then by the American psychologist Joseph Jastrow, who used it to conclude an essay on subjective perception. See Joseph Jastrow, "The Mind's Eye," *Popular Science Monthly* 54 (1899): 312. See also John F. Kihlstrom, "Joseph Jastrow and His Duck—Or Is It a Rabbit?" 2004, http://socrates.berkeley.edu/~kihlstrm/JastrowDuck.htm.

3 Ludwig Wittgenstein, "Rabbit or Duck," *Philosophical Investigations,* ed. and trans. G. E. M. Anscombe (Oxford: Blackwell, 1953), 194.

4 Gombrich, *Art and Illusion,* 5–6.

5 Unless otherwise noted, all quotes from the artist are taken from a series of interviews between this author and Amy Blakemore in Houston between July and August, 2008. Similarly, all the chapter titles in this essay are taken from these conversations.

6 Chrissie Iles's and Philippe Vergne's "Draw Me a Sheep" project was a special segment of the catalogue that complemented the physical exhibition. See the curators' introduction in *Whitney Biennial 2006: Day for Night* (New York: The Whitney Museum of American Art, 2006), 13, plate 8.

7 In 1976 John Szarkowski organized the first exhibition of color photography at the Museum of Modern Art, *Photographs by William Eggleston.*

8 Blakemore has stated: "My favorite things there were the shrunken heads, the grand piano covered in tree bark, and the best, the giant dead buffalo that had a sensor in its mouth that activated a vacuum to suck garbage into its body when one held trash in front of its face."

9 These dramatically charged illustrations were promoted as tools to unlock repressed fears. Now largely discredited, they nonetheless remain remarkably potent images, fraught with sexual despair and alienation.

10 Perhaps with some irony, Blakemore has cited Walker Evans, and in particular the photographs of *Let Us Now Praise Famous Men* (1941), in reference to this image. While still living in Springfield, Blakemore submitted the work to a library exhibition, *Your Life in Southwest Missouri,* where it was awarded first prize and was published in the local paper.

11 Russell Lee taught at the University of Texas at Austin from 1965 to 1973, and he remained a powerful presence on campus until his death in 1986. Garry Winogrand succeeded Lee, serving on the UT faculty from 1973 to 1978.

12 Blakemore has acknowledged the parallel between this series and the work of Jim Goldberg; however, she did not discover Goldberg's story photographs until several years later.

13 A one- to two-year art residency, the Core Program had been launched at the Museum of Fine Arts, Houston, in 1982 by Allan Hacklin, director of the Glassell School of Art, and Rachel Hecker, assistant director. For a full history of the program see Joseph Havel, Alison de Lima Greene et al., *Core: Artists and Critics in Residence* (Houston: The Museum of Fine Arts, Houston, 2008).

14 Amy Blakemore, as quoted in ibid., 29.

15 Michael Miller, as quoted in ibid., 34.

16 Kristin Musgnug, as quoted in ibid.,58.

17 Blakemore has recalled that during the 1986 Houston FotoFest, one editor had initially responded very positively to her portfolio, and then dismissed her work on learning

she was using a Diana: "Well, you come back and see me when you can take pictures with a real camera." Since Blakemore already had a closet full of "real" cameras, she took this statement as more of a challenge than a criticism.

18 Anne Wilkes Tucker has written eloquently on *Three Girls*: "Amy Blakemore's photographs are . . . about specific things and memory. The photographic details shape and define a viewer's response; the hazy focus of the Diana camera that Blakemore prefers encourages the viewer past the specificities and stimulates memories. I become the child hanging from her raised hands. I can feel my body weight pulling on my sockets." Anne Wilkes Tucker, "The Many Forms of Memory," in *Amy Blakemore: Ten Years* (Houston: Inman Gallery, 1999), 3.

19 Susie Kalil notes of Blakemore's pilgrimage photographs: "Although Blakemore aimed to document the individuals who received solace from the shrines, the journeys became her pilgrimages as well. They took her over strange byways she would not have ordinarily traveled, providing her with sights and experiences she would not otherwise have encountered. . . . By making these journeys, Blakemore behaves no differently than pilgrims who have gone before." Susie Kalil, "Amy Blakemore: Ten Years," in *Amy Blakemore: Ten Years*, 19.

20 Blakemore has admitted to a passion for movies that dates back to childhood. While still in high school she had a Super 8 camera, and for a while she tracked her walks around Tulsa with informal short films.

21 Writing about this series of portraits, Barry Schwabsky celebrated the musicality of these images: "The inherent but variable effects of blur, of bleeding light, of vignetting, and so on function like a blues musician's bent notes and feedback, turning the most straightforward visual riffs into something sly and oblique." Barry Schwabsky, "Amy Blakemore at Inman Gallery," *Artforum* 41, no. 2 (October 2002): 158–59.

22 It is worth noting in this context that Harlow was commissioned by the sitter as a wedding portrait.

23 John Szarkowski, *William Eggleston's Guide* (New York: Museum of Modern Art, 1976), cover.

24 *Flag* was taken in a guesthouse in Medjugorje, a pilgrimage destination in Bosnia and Herzegovina. Blakemore visited the region shortly after the Serbo-Croatian War (1991–95).

25 Anne Tucker, *Amy Blakemore: Ten Years,* 4.

26 Susie Kalil, *Amy Blakemore: Ten Years,* 16.

27 Michelle White, "Amy Blakemore's Ephemeral Archives," *Gulf Coast Literary Magazine* 19, no. 1 (Winter 2007): 140.

28 Nancy Rexroth, *Iowa* (Rochester, NY: Violet Press, 1977), unpaginated.

29 Ibid.

30 Amy Blakemore, quoted in White, "Amy Blakemore's Ephemeral Archives," 138.

31 Amy Blakemore, from a statement prepared for the Aperture West Book Prize, June 6, 2008.

PLATES

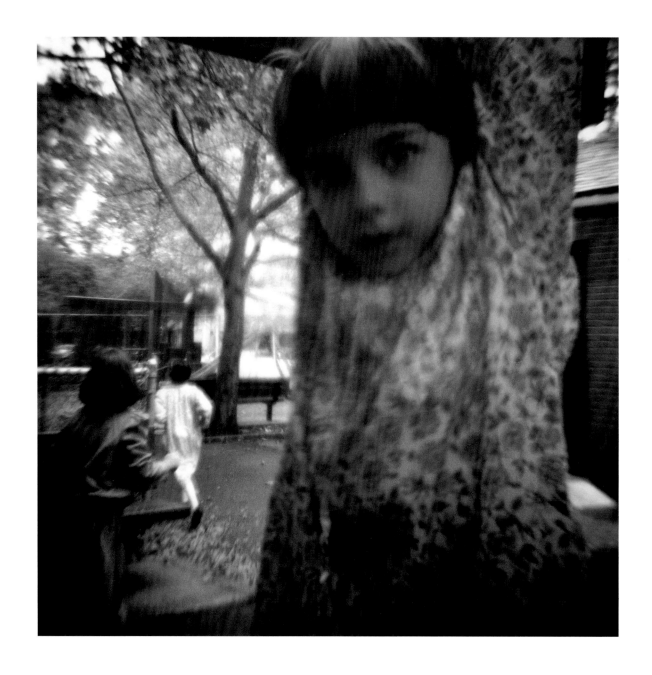

Three Girls 1988

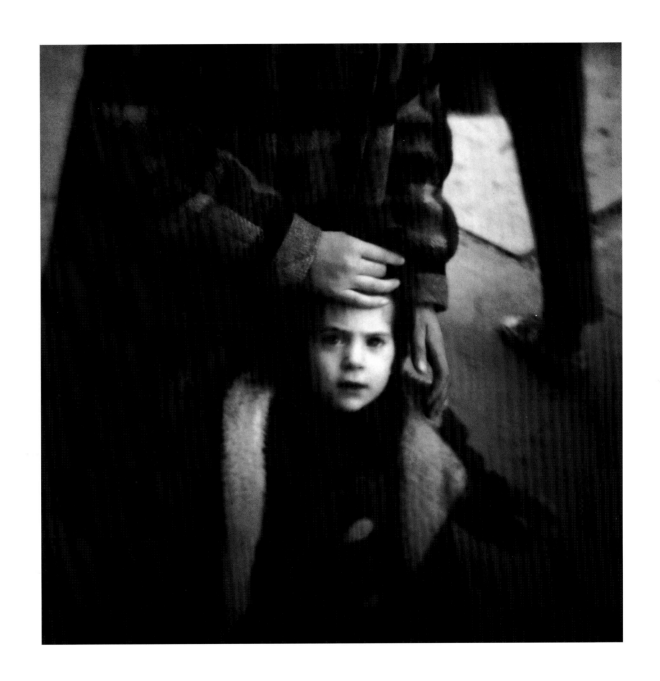

Child 1988

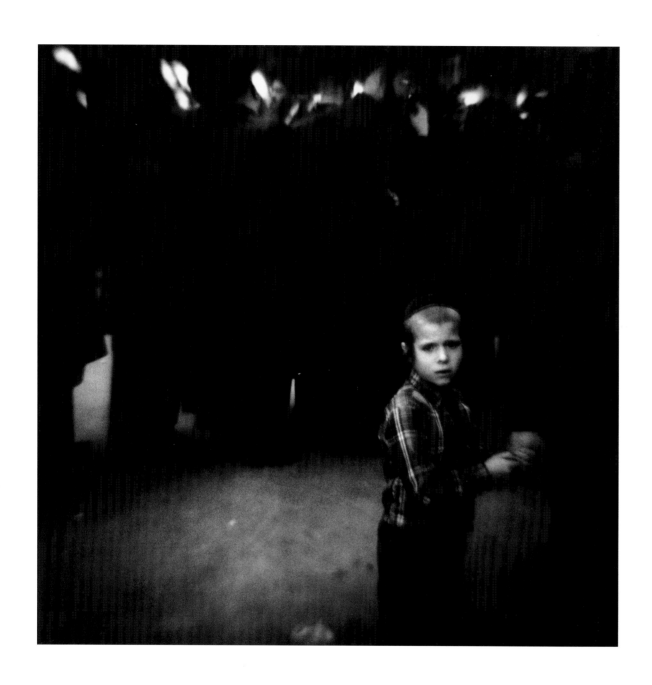

Boy and Men 1989

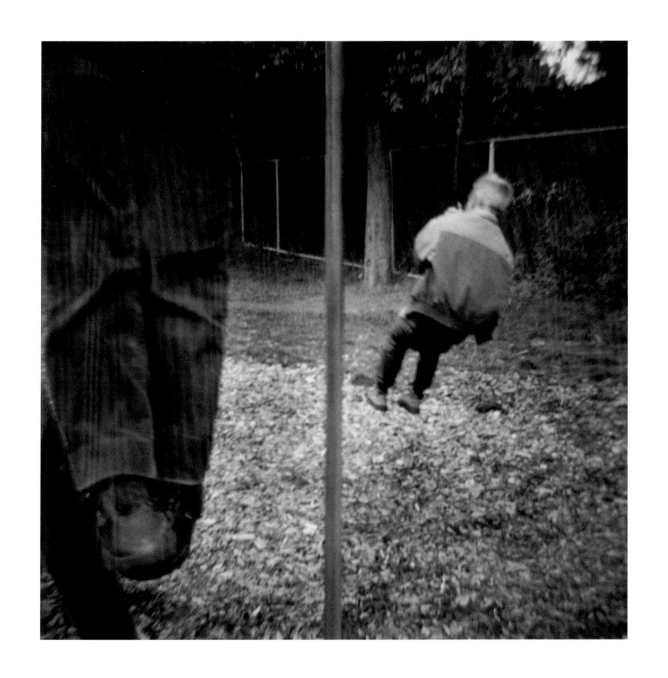

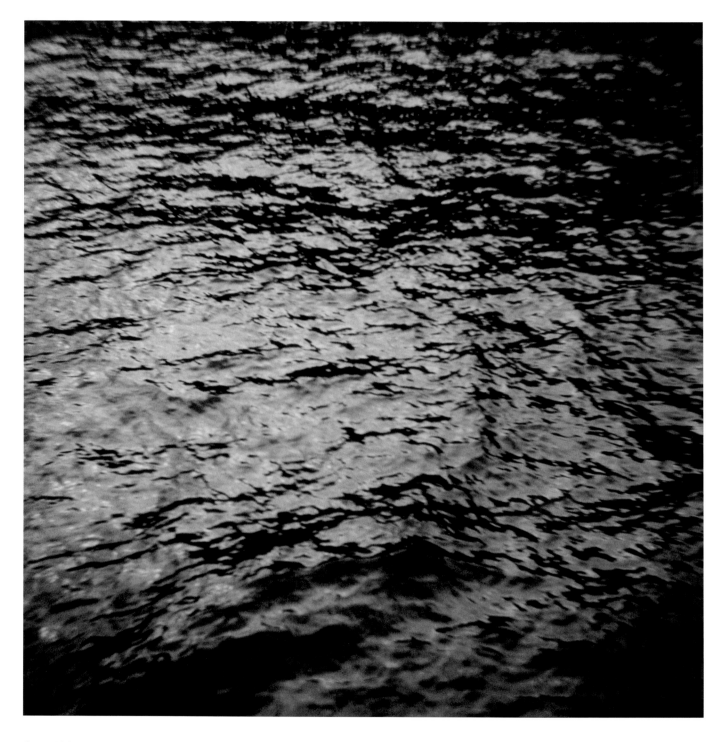

Sea 1997

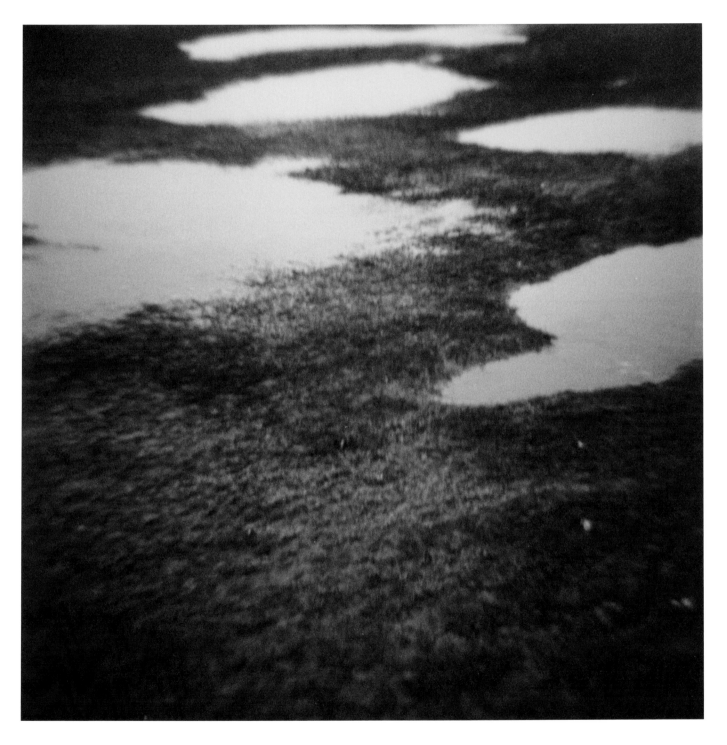

Pools 1997

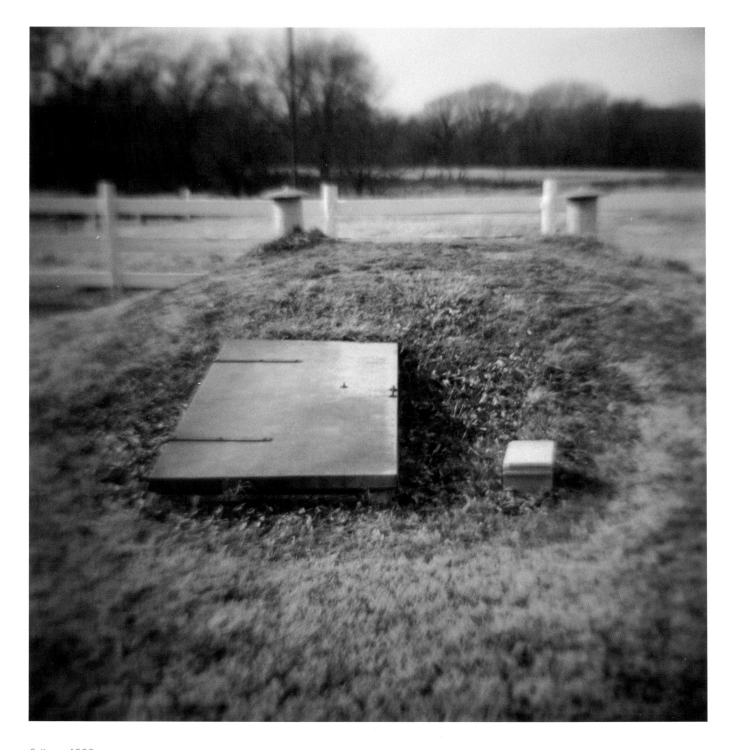

Cellar 1999

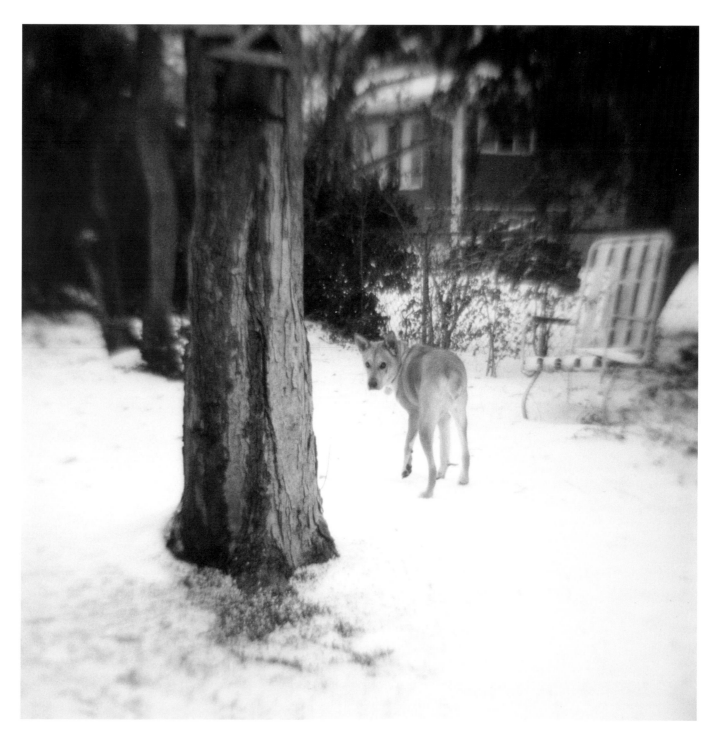

Dog in Snow 2004

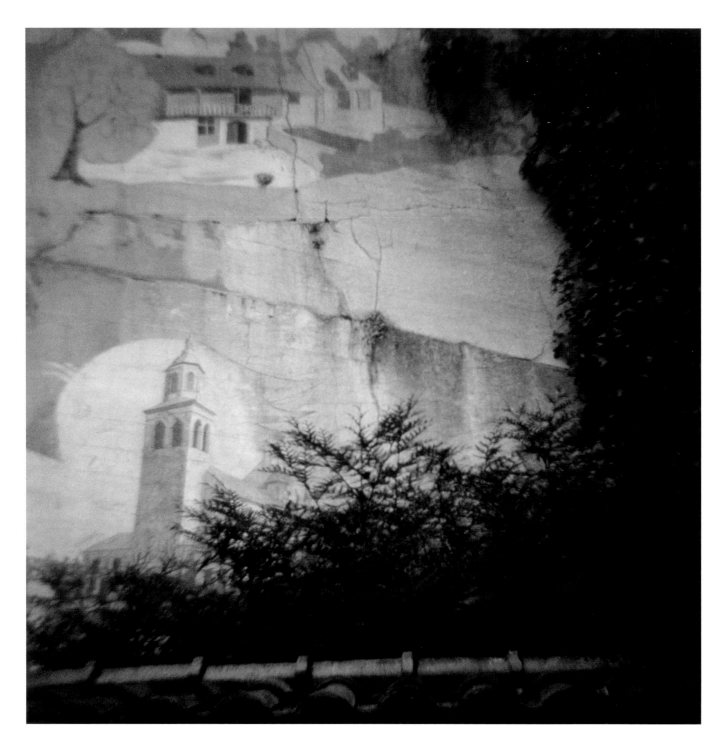

Astoria 1998/2008

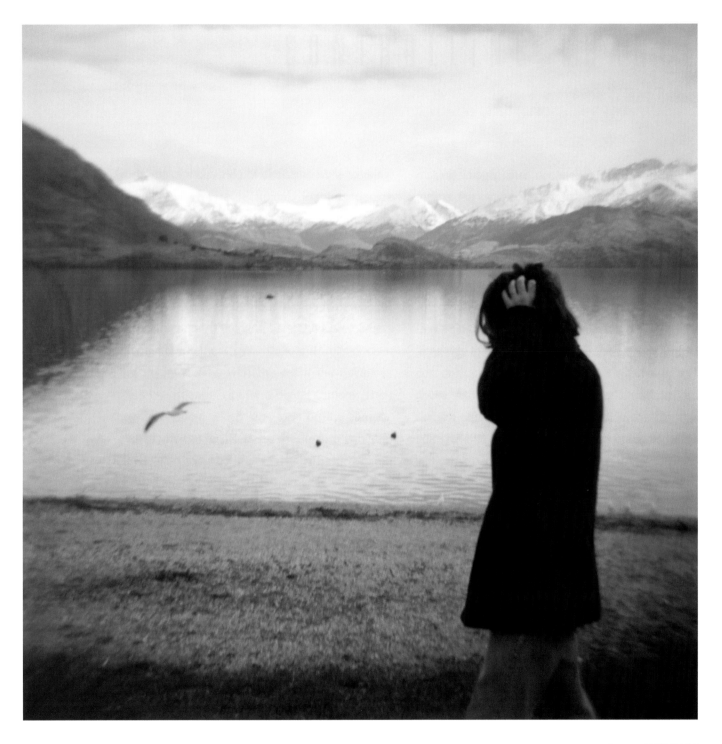

Pam 1997/2008

Fig. 1 Amy Blakemore, *Steven*, 1997, chromogenic photograph, 19 x 19 inches (48.3 x 48.3 cm).

IN DARKNESS AND IN LIGHT

Marisa C. Sánchez

Amy Blakemore is an intuitive storyteller with a profound ability to interpret sensations, which results in images that reveal her vulnerability and her tender perception of the world. Her work probes a vivid history of personal experience, offering intimate and sensitive encounters with family, friends, strangers, and places both distant and familiar over a period of twenty years. Blakemore's stories are told through her deeply suggestive photographs that are often about absence and loneliness, abandonment, and sometimes fear—images that inspire the viewer to imagine much more beyond their borders. Her photographs recall Italo Calvino's observation that images "develop their own implicit potentialities, the story they carry within them. Around each image others come into being, forming a field of analogies, symmetries, confrontations."[1] In Blakemore's photographic practice, images "carry within them" the complex narrative woven by the photographer, as author, of her personal "visual diary."

Blakemore has said that her camera gives her permission; it grants her access to the subject matter she wants to record.[2] She has photographed in diverse locales such as Oklahoma, Missouri, Texas, New York, Massachusetts, France, London,

and Bosnia and Herzegovina. However, the resulting images most often do not reveal the specifics of location, but are more a reflection of the artist's observations of the subtleties of an experience with objects or people, translated in a manner that does not define a place, but interprets her connection to it. For instance, *Flag*, 1999 (see page 53) is a seemingly banal image of a flag made of red and white plastic carnations outlined by artificial ferns and affixed to a wall. The image provides no definitive clues about the surrounding environment. In explaining why this object caught her eye, Blakemore has said, "It was just something I looked at every morning at breakfast and I thought, 'That is the weirdest thing I've seen.' I loved it. I want one of those."[3] So she took a photograph as a way to hold onto that object and preserve the memory of her encounter with it.

This act is not unusual among photographers. Walker Evans often literally took the object he photographed. Jerry L. Thompson has noted: "Frequently on his excursions he [Walker Evans] would photograph a sign and then remove it, if possible, and take it with him... The photograph had always been his way of making clear exactly what it was that had

THROUGH THE LENS

Chrissie Iles

In the enigmatic photographs of Amy Blakemore, the eternal triangle of photographer, subject, and viewer occurs through an acutely sensitive registration process that is, in equal measure, psychological and material. Unlike painting, the photograph, as Roland Barthes famously observed, is inseparable from what it represents; the two are "glued together like the condemned man and the corpse."[1] Blakemore's statement that "the pictures serve as a visual reminder but also as an emotional reminder" echoes Barthes' argument that the photograph does not so much call up the past as attest that what we are seeing once existed.[2] Both the photographer and the viewer are, as a result, the reference of every photograph, together drawing the baseline of a triangle at whose apex is the subject.

The emotional intimacy of this experience is framed by the physical construction of Blakemore's images. Each one is taken using a Diana camera, a 1960s mass-produced plastic box camera that produces square-shaped pictures. The basic design of the camera and its susceptibility to light leaks strip away conventional expectations of technical photographic "professionalism," producing images that have a darkly shadowed handmade quality, evoking early experiments with light and the photographic apparatus. Blakemore's "flawed" photography brings to mind the photographic experiments of Sigmar Polke, in which technical "mistakes" form an integral part of the image. The strong chiaroscuro of each picture and the often circular trace produced by the Diana camera's lens suggest the fragile and deeply subjective mechanics of vision, by which the image can be distorted, filtered, or otherwise altered by blurred vision, partial blindness, or hallucinations.

Blakemore's dark images confirm Goethe's statement that opacity is an essential component of vision. As Jonathan Crary explains, Goethe argued that "perception occurs within the realm of . . . 'das Trübe'—the turbid, cloudy, or gloomy."[3] The realm of Goethe's "das Trübe" is the body, that imperfect, subjective, coded location of perception that makes any kind of empirical definition of vision impossible. Blakemore's shadows suggest a dreamlike state from which the image, a cipher of memory, gradually emerges, appearing as though from the surface of a daguerreotype, or from an interrupted chemical process in the developing tray.

The tension between the almost deadpan quality of Blakemore's technique and the intensely psychological and emotional subjectivity of her formally constructed compositions is played out through her use of shadow, which, in her most personally charged photographs, becomes painterly. In one of her most powerful photographs, *Dad*, 1999 (see page 56), her father lies dead in a hospital bed, hands clasped, draped in a sheet, his body visible only from his chest downward. The light from a nearby window falls onto the folds of the sheet and faintly illuminates a barely visible picture on the wall above him. The picture has a calm, peaceful quality, its spare, classical composition evoking Jacques-Louis David's painting *Death of Marat*, 1793, or Mantegna's *The Lamentation over the Dead Christ*, c. 1490. Blakemore's use of chiaroscuro transforms the hospital room into an intimate, painterly, and ambiguous space. It is the simple, direct, childlike title that locates the image in the realm of the family photograph, transformed, in Blakemore's hands, into an elegant and somber contemplation of death.

As Barthes argues, a photograph of a dead person creates a living image of someone dead, just as a photograph of a living person contains the sign of their, and our, future death within it. In many cases, a photograph captures someone who was alive when the photograph was taken, but who is now dead. This paradox generates what Barthes calls "the stasis of an arrest." The photograph "blocks memory, [and] quickly becomes a counter-memory."[4] *Dad* is from a group of photographs Blakemore made during the time of her father's death, each of which has the haunting quality of something captured just before it disappeared. In *Workshop*, 1999 (see page 57), Blakemore's father's workshop is photographed in deep shadow with light falling across the door. On the other side of the door hangs her father's work shirt, its collar and sleeves evidence of his recent presence. The tidy drawers and boxes suggest a neatness of things put carefully away, perhaps never to be taken out again.

The picture conveys a sense of what Duchamp termed "infra-mince," or "infra-thin"—the barely registered trace of a recent presence, described by Duchamp as resembling the moment just after someone has got up from a chair. *Dad* presents to us the reason for the absence in *Workshop,* creating a wrenching gap that, like the gap

between the moment registered by the camera and our later experience of it at one remove, can never be bridged.

In a recent portrait, *Mary*, 2008 (see page 54), Blakemore photographs her mother in a deep shadow that cuts across the picture horizontally, obscuring her face from just above her mouth. The shadow softens her mother's stiff pose, making mysterious her self-consciousness in front of the camera. Blakemore diffuses the artificiality of Mary's pose by placing the emphasis on the relationship between her half-smiling mouth and the amplifier hanging round her neck below it. The amplifier, there to augment the speech of others to Mary's deaf right ear, becomes, in the photograph, an echo of her own mouth, as though amplifying its sound at a moment, late in her life, when she appears to be fading into the shadow.

What Maurice Blanchot termed "absence as presence"[5] pervades Blakemore's quiet photographs. Absence is present in an empty Boston street, an empty driveway leading to a small garage, an expanse of water or sky that fills the frame of the picture, a pile of seemingly abandoned shoes, or a hatch door to a cellar, set into the ground. The closeness of Blakemore's viewfinder to her eye is palpable; the relationship of what she saw when she chose to press the shutter button, how she draws out the image from a faintly exposed negative in the darkroom, and how she manipulates its light render each image profoundly corporeal. The trace of shadows in the periphery of all Blakemore's photographs marks their origins in a mechanical extension of sight that is as ordinary as a weekday, and as profound as Goethe's opaqueness of vision.

NOTES

1 Roland Barthes, *Camera Lucida: Reflections on Photography*, trans. Richard Howard (London: Flamingo [Fontana Paperbacks], 1984), 6. First published in 1980 as *La Chambre Claire* by Editions du Seuil; first English translation published in 1981 by Hill and Wang.

2 Ibid., 82.

3 Jonathan Crary, *Techniques of the Observer: On Vision and Modernity in the Nineteenth Century* (Cambridge, MA: The MIT Press, 1992), 71.

4 Barthes, *Camera Lucida*, 91.

5 Maurice Blanchot, quoted in ibid., 106.

CONVERSATIONS WITH AMY BLAKEMORE

Alison de Lima Greene

Note: *The following text is extracted from a series of conversations between Amy Blakemore and the author in July and September, 2008. Other statements from these interviews also appear elsewhere in this publication.*

Alison de Lima Greene: I thought it would be interesting to start with what you have called your first photograph (*Untitled,* 1979, see page 15). What led you to this subject?

Amy Blakemore: I have always been fascinated by faith healing. When I was a kid, my little brother and I would watch the Sunday morning "Rise Up and Be Healed" show on TV, which really made my mother upset. We found it very very entertaining, but she made us stop watching it.

In 1979 I was in college [Drury College] in Springfield, Missouri, and this was, I think, when I was taking my first class in photography. I took some pictures of a service that friends took me to one night.

AG: Was it at college that you first got involved with photography?

AB: Actually, I started taking photographs when I was in fourth grade. My dad took me to Oertle's Department Store and got me a Kodak 44 (126 cartridge) when I was on my way to Girl Scout camp. It was $9.95. I took a lot of pictures of my cat.

In seventh grade I asked for and got a Polaroid Swinger. Because the film was so expensive I didn't take all that many photos with it. However, about ten years ago I found a few of the portraits I'd taken with that camera and was struck by how the structure was not so different from those taken many years later.

AG: Aside from Sunday mornings with "Rise Up and Be Healed," what caught your imagination as a child?

AB: I was fascinated by unusual deaths, medical oddities, and murder. For example, from 1968 to 1969 I kept a scrapbook, a taped-together folder really, of articles from the Tulsa newspapers and the

Weekly Reader from school. I have the Manson and Zodiac murders among others, and a series of articles about Philip Blaiburg, who at that time was the longest-living heart-transplant recipient.

I don't know exactly why I was so interested in death and murder, though I do remember wanting to make a tabloid, like the ones you see in supermarkets. And these articles came in handy for telling stories around the campfire.

I also loved the movies, and you could still see all the great ones on TV. I saw old black-and-white films of the thirties and forties, major classics, and lots of B films. In seventh grade, I cut the descriptions out of my grandmother's *TV Guide* to make my own movie guide.

AG: Was there a moment when you began to get more serious about photography?

AB: When I was in tenth grade, I told my parents I was going to quit school if they didn't sign transfer papers so that I could attend Booker T. Washington High School [BTW]. I guess my parents believed me, because they signed the papers. Tulsa was a very segregated city, and BTW was on the other side of town. Tulsa ISD was "experimenting" with voluntary busing and trying to avoid the conflicts that were happening over forced busing in other parts of the country at that time. In order to bribe the white students to transfer, BTW offered a variety of amazing classes, among them, photography. I wanted to go to BTW regardless, but that photography was offered cinched it for me.

AG: But you didn't see photography as a career when you got to college?

AB: I majored in sociology and psychology, and my plan was to attend Washington University and earn dual degrees in social work and law. I waited until my senior year to take the required two art classes in order to graduate. But I continued to take photographs constantly. I set up a darkroom in my dorm, and one year was the photographer for my sorority.

When I finally got around to filling my art requirements, the photographer Michael Dickey had just begun to teach at Drury, even though we didn't have a real darkroom on campus. I don't really remember how it all happened, but Mike saw my pictures and told me not to change a thing, just keep doing what I was doing. After working with Mike, I knew I didn't want to go on to grad school.

I just wanted to make photographs, but I really had no idea what that meant.

After graduation, I continued to take classes with Mike, as well as with Tom Parker, another member of the adjunct faculty. I had to get a job, and was extremely fortunate to get a counselor position working 11 p.m. to 7 a.m. on a closed psych unit at a city hospital. I still see the faces of the patients and remember their names and stories. All I did for two years was work, make photographs, and sit in the park or square every day. I took classes like drawing, printmaking, painting, and design, but I really only made photographs: in the drawing class, I ended up doing a photo essay on a painter, Robert E. Smith, same with sculpture.

AG: Then what came next—the master's program at UT [University of Texas at Austin] and the text photographs?

AB: I kind of floundered my first year at UT [1982–83], and didn't really know what I was doing. By my second year, I was driving over to San Antonio a lot. I used to talk to people on the streets, downtown by the Alamo before it got fixed up. They weren't homeless, just people hanging out on the street. I'd

say "Hey. What are you doing?" And they thought I was some sort of undercover person, always. "You a cop?" "No, I'm not a cop." So we'd talk, and I would take pictures.

I think I was looking for meaning. How could these people without anything, or not much, seem so happy? And then I started doing the narrative pictures—the first were black-and-white, but then I switched to color.

Jim Goldberg was doing something similar at the same time, and a little bit before, in San Francisco, but I didn't know about him until I was a Core Fellow [1985–86, at the Museum of Fine Arts, Houston (MFAH)]. It was George Krauss who first told me about his work.

AG: And then the Core Program here in Houston. You recently said that it was Rachel Hecker [then assistant director of the MFAH's Glassell School] who pretty much cudgeled you into coming down here.

AB: Rachel said, "Just send me everything you have," which I did. I sent her the stuff that was in my thesis show. At the time, I was much more into my documentary color work, in particular the Alamo Hotel project.

But I'd taken two or three rolls with this plastic camera that I thought was really stupid. Turns out I was accepted on the Diana pictures.

AG: Was this first time you used the Diana camera?

AB: I picked one up my last semester of graduate school [1985]. My teacher Ellen Wallenstein was using the Diana, as was this other friend, and I thought, "I'll just try it." I did a couple of rolls and thought it was a stupid idea and camera, but I was trying to relax. The Diana made it really easy for me to take pictures of other people; it was just too easy, I thought.

AG: Were you aware of Nancy Rexroth's Diana photographs?

AB: When I started using the Diana, I mentioned it to Mike Dickey back at Drury. He had gone to school with Rexroth, and he told me about her work. Some years later I discovered her *Iowa* book—I have a copy somewhere.

AG: Did you see the Diana camera as a means of getting away from the kind of documentary work that was still being promoted by UT and other schools?

AB: Well, not at the time. I think it was because I was tired of taking the pictures I was taking. I was horrified and shocked when I found out that I got into the Core Program based on the Diana pictures and not my other ones. I really did say "Oh my god, what am I going to do?" But I came around.

AG: What about Susan Sontag's essay *On Photography*? What did you think of her discussion of the camera as a weapon?

AB: I had a copy, but I didn't finish reading it. I don't see the camera as something aggressive, but as more of a protective device, something to put between you and something else.

I use the Diana camera as a tool, but I don't like it to be identifiable as a Diana, actually. For example, the vignettes—dark corners—there's only so much I can budge. It took me a while to figure out how to use the Diana in a way that I liked.

AG: So what is it about the Diana that you like?

AB: It produces the results I am after and allows more spontaneity. But at the same time, it creates problems I have to solve if I want a particular picture.

While it is very frustrating sometimes, especially when I know a quick fix in Photoshop would take care of the problem quickly and easily, I still enjoy trying to figure out how to solve it. Sometimes I spend hours only to find that I just can't fix it.

AG: Do you have certain criteria that rule your darkroom practice?

AB: One summer in grad school, I decided I would not crop in order to force myself to pay better attention to my compositions. It's a habit now. I am not opposed to cropping; I just never think to do it. I look at the negative as a whole. However, if there is a defect in the negative close to the edge, I will crop to make the image clean, to eliminate the uneven edge that the Diana produces; it's negligible.

Also, it drives me crazy when the grain is not completely focused. I've spent many hours aligning my enlarger to get all of the grain in focus. The negative that comes out of a Diana is not of the quality one would expect from a traditional camera. I often impose "normal" or "correct" printing rules to the Diana negatives, but I am trying to become more relaxed about that. I hardly ever burn, and I rarely dodge. If I do dodge, it's usually the corners,

because I don't like the vignetting a Diana often gives, or I might dodge the sides some. Usually there's just not enough negative to dodge in the darker areas.

AG: We start the exhibition with *Three Girls* (see page 32), the first picture of yours that entered this museum's collection.

AB: Clint Willour picked it out for the MFAH, and it seems to be one that a lot of people respond to. People tend to identify with the image—it becomes a kind of reflective self-portrait. A friend of mine, a psychologist, nailed it: "That could be anyone. That's all of us."

AG: Where was it taken?

AB: Roebling Park, Brooklyn. It's in Williamsburg, back before Williamsburg was hip.

AG: Was this part of Brooklyn's Hassidic community?

AB: Yes, they were Hassidic girls. I don't think I took many pictures that day. I usually don't. With the Diana you click, and then you have to wind it up to the next number and make sure you leave adequate space between shots. And then you have to

look again, so it's not like "boom boom boom." I really didn't know how to develop film very well back then, or how to compensate for the problems of using this camera.

AG: The running figure in the background comes up in your pictures a number of times during this period—reminding me of Henri Cartier-Bresson's work. Was he someone you were thinking about as you developed this series? Were you conscious of his credo of "the decisive moment"?

AB: No, I wasn't thinking about any of that. I was just responding to what I saw.

There are people who make/made work that I greatly admire, but I don't know how to say they influenced me. The word *inspired* has more meaning to me than *influence*. The first photographers I was really conscious of were Diane Arbus and August Sander, and of course there were other people I came to know later. But you have to remember—this was before the Internet—getting access to images wasn't as easy as it is now.

AG: A lot of the work you did in the late 1980s and early 1990s was focused on children. And you often capture them at moments when they seem vulnerable in one way or another.

AB: That wasn't a conscious decision. It's more like staying around to see what happens. When I started putting these photographs together later, this thread emerged. They all have this vulnerability.

AG: However, I don't see these as particularly sentimental pictures.

AB: I don't feel like they're sentimental at all. For me, they're a little ominous. In *Boy and Men* (see page 34), this scared-looking boy is holding this big guy's hand, probably his father's. At first the background appears anonymous, but I like how you can see the faces of the men, too.

AG: You strike a very different note with *Swing* (see page 35).

AB: That was taken in Amsterdam.

AG: I love the classicism of this composition, the strict division made by the central pole and the jump between foreground and background. I also think you're making a lot of stringent choices in the darkroom.

AB: Looking at the negative or wet film, if I feel that someone has punched me in the stomach, then that photo is a good one.

AG: What about the square format of these pictures? It's also something that the Diana favors, although of course this is also true of a number of high-end cameras.

AB: Yeah, I have a lot of cameras. What did I have that had a square? I had a couple of Rolleis that I like a lot. There are some other formats. But the square, I love the square.

AG: Didn't Arbus embrace a similar format?

AB: Yeah, she used a Rollei, a twin-lens reflex camera from Germany.

AG: With works like *Cloistered Convent* (see page 36), you launched a series dedicated to European pilgrimage sites: Lourdes, Fatima, Medjugorje. You're not looking for personal healing, I think.

AB: No, I'm not looking for healing. I'm wondering how people are comforted by this, by how it works, because I'm not religious like that. How did they find meaning in this place, and vice versa, how would I? How do you believe in things like the faith healing, or speaking in tongues?

And I had just gotten a travel grant from the Dallas Museum of Art, which made it possible for me to go to Europe.

AG: *Adam* (see page 40) was a surprise to me when we first started going through your archives; I don't think I ever saw this portrait before. Is it something of a turning point in your work?

AB: I always did portraits. I always took pictures of people, and I never imagined a time when I wouldn't. And of course, with Adam, it wasn't "Oh, there's an uncomfortable silence. I'll just take some pictures." It was just because the light was really pretty. And I liked his nose.

AG: There's this device here that you pick up again later, slicing the face with shadow. I'm thinking of a related photograph of your mother (see page 54). Isn't this the sort of thing you're supposed to avoid in portraits?

AB: I didn't see it that way. They say you're not supposed to put stuff in the middle.

AG: In the mid-1990s you started to shoot exclusively in color. Do you ever think you'll go back to black-and-white photography?

AB: Well I hope so, but I can't do black-and-white at the same time as color. It's a different way of seeing. Also, color printing itself is boring; black-and-white is much more fun to do. One day I'll probably be forced to go back to black-and-white, since most of the materials I use for color work are becoming less and less available.

AG: Why did you go into color?

AB: I don't know. Well, in graduate school it was a deliberate decision to break with my professors. And then in 1995, I took some color film when I went to Fatima, where I took *Cod* (see page 44). Somehow after that trip, I was taking color. It wasn't something I thought consciously: "I'm going to do color now."

AG: Light and color certainly burst out of pictures like *Steph* (see page 41). My first thought when I saw it was "Good God, this is such a wholesome American image!" This picture always seemed to me as wildly, even romantically, iconic. Where was it taken?

AB: Not far from Houston, out at a friend's farm. The light out there is amazing. I've taken several pictures out there in that light. It really is that color.

AG: *Harlow* (see page 43) is a little unusual among your portraits in that it was commissioned, right? Wasn't it her wedding gift to her husband? How did you arrive at this unusual point of view?

AB: Yes, it was commissioned. I didn't think I did very well with pictures like that. I'm better with spontaneity. But the light was really strong, and Harlow was wearing this amazing red dress. I ended up taking eleven rolls, because I was so worried I wasn't going to get anything she liked. Then we ended up choosing this one, the seventh in the first roll. Now I'm much more comfortable with projects like this.

AG: In the mid-1990s you took a lot of pictures that showed a real shift in focus, a move toward more abstract, overall compositions. In pictures like *Cod,* rather than focusing on an incident, you seem to be

more concerned with filling the frame. I also see *Apples* (see page 42), among other works, as part of this group.

AB: *Cod* and *Apples* were from the same trip. *Cod* was taken in Nazaré, a town on the sea, twelve miles from Fatima. *Apples* was taken when I was visiting Maria Rojas in South London, and we went to Sissinghurst, Vita Sackville-West's castle and gardens. It was such a beautiful place. I just initially responded to the light.

AG: *Sea* (see page 46) is all about light.

AB: Well, there's nothing else to take pictures of there.

AG: Which sea was this?

AB: The Tasman, in New Zealand. It was my first trip there, and I thought, "What am I going to take pictures of? It's all outdoors."

I first went over to Milford Sound, but it was closed because of avalanches. Then I went on this boat trip at Te Anau, on the southern end of the island. This was taken on the boat.

AG: What is it about traveling that inspires you to take photographs?

AB: I take pictures because I'm in someplace new, somewhere fresh. In New Zealand, I was there for a month. I saw my friends Pam and Doug for about two weeks, and then I traveled for two weeks.

AG: So when you travel, it's to visit places and friends, but…

AB: It's to take pictures, too.

AG: Photographs like *Fairgrounds* (see page 51) don't seem as exotic.

AB: Well, yeah. They're in Tulsa.

AG: It seems to me that your work of the late 1990s represents a new, even "Midwest" sensibility—an embrace, if you will, of a kind of regionalism.

AB: Some people have called this work "Southern." About twelve years ago, I was in a show organized by the Birmingham Museum of Art, *The South by Its Photographers.* Here's the statement I made then:

[These photographs] are about the affection I feel for my hometown of Tulsa specifically, and the South in general. I am giddy and laugh every time I see Oral Roberts' sixty-foot hands or when I remember the petition drive to paint pants on the Oilman at the fairground because someone deemed the monument obscene.... I love the incredible winter light and how weird the South and its people are. It's all just a little bit off.[1]

When I was visiting home, I didn't want to hang out in my parents' house all day, so I would go around in a car. I wanted to make a record of stuff that was old, places in my neighborhood I wish I had photographed earlier. A lot of these pictures are architectural, but again, it was the winter light that I wanted to capture, too. These buildings are gone now.

AG: Some of my favorite photographs are of your immediate family, your parents, your uncle.

AB: I photographed my uncle from the start. He's probably one of the first pictures I took with my Diana. It was when he was still working on his farm, which was a really special place for me.

AG: Your portrait of him, *Jim* (see page 55), is one of those pictures that seems to have an almost calculated balance, beautifully composed with light and shadow; even the suspenders describe a perfect arc.

AB: A lot of the color and texture is because he was looking out his kitchen window. I don't think he actually knew I was taking his picture.

AG: This was taken through the kitchen screen?

AB: Yes, I was standing outside the window, looking in at him.

AG: And then looking at *Dad* (see page 56), I can't believe you were able to take this picture at all.

AB: I can't either. My mother never knew anything about it.

AG: This one was when he was in the hospital?

AB: This was after he was dead. I waited until my mother and brothers left the room.

AG: I know that your negatives are almost invisible in some cases, that you pull a lot of information out of very little.

AB: *Dad* is barely there. It's such a thin negative, you can't really see it. I was using film that was really fast, but super grainy, and I knew I'd have to have to push the film. Two stops is max, and it's still barely there, but if I hadn't pushed, it would never have come out.

AG: Have you shown this photograph to your brothers?

AB: I showed it to my little brother about a year or two ago, and he said, "Oh. That's not as bad as I thought it would be." So it's okay.

My other brothers haven't seen it. I told one of my older brothers about it, and he said "You know, people don't need to see stuff like that. You just don't need to see some things." My father was actually the first person I saw dead.

AG: Am I wrong to think of *Dog in Snow* (see page 59) is tied into you father's death?

AB: No, it is. That's my dad's dog.

AG: Even though it was taken five years later, it seems like a coda to me, along with *Workshop* (see page 57).

AB: All three of these go together. That was my dad's workshop, and I took that picture at the time we found out he was going to die. My little brother and I were sitting out on the patio, kind of crying, and someone called us.

That's one thing about pictures, photographing makes me remember things. It's personal stuff like that, like being with my brother as my dad died. That doesn't have any meaning for anyone else.

AG: The issue of memory and collecting images seems to become important at this point in your work. This was perhaps implicit before, but it was something you emphasized last year when Michelle White wrote about you in *Gulf Coast.*[2]

AB: It's always a collection, a visual diary. A lot of these pictures are about what I was seeing. It's something that gives me access to myself without giving it to others.

AG: I know I was thrown off the first time I saw *Monument* (see page 64), which for Houstonians, at least, is specifically located. The looming figure and strange light are just as weird as the Sam Houston monument itself.[3]

AB: I was visiting the Texas Prison Museum in Huntsville with Jill Wood and Debby Breckeen. We were really just out for a drive.

AG: This was nighttime?

AB: No. It was probably around midday. Not a time I like to shoot.

AG: Both *Monument* and *Jill in Woods* (see page 65) look like those day-for-night shots in movies.

AB: Where you put the filter on? No, it's the crappy film. I don't know this for a fact, but it seems like there is a bias toward blue using a Diana camera. Also the Konica 3200 film isn't meant for daylight. Which when I found out they weren't making it anymore, I bought up as many rolls as I could. It's a really fast film. It's super grainy, and it was old when I got it, and I'm supposed to keep it in the freezer, and I didn't.

When I'm printing, I pay attention to a lot of technical things, but when it comes to the film and the camera, I'm pretty lackadaisical. I probably should have been doing research on a better film, but I didn't.

AG: And then these last two pictures, which, even though they were made from negatives that were shot earlier, you've identified as new work. *Astoria* (see page 66), when was it shot?

AB: Whenever the last pilgrimage trip I went on. It was 1998 or something.

AG: Why didn't you want to print it until now?

AB: When I was first looking through my negatives, that stacked space wasn't something I would have responded to. But I always had it in my head.

Then the one of *Pam* (see page 67), it was like I'd never seen it before. I was going through my negatives, looking for some of the pictures I needed to make of New Zealand, and I thought, "Why didn't I ever print that one?"

AG: How did you get that collapsed perspective in the *Astoria* picture?

AB: I was sitting in the courtyard of this sort of decrepit hotel, which I really liked. Again, just looking at this above that, it was just weird.

AG: And the New Zealand landscape is so postcard-perfect that Pam has to cover her head.

So how come you take such good pictures?

AB: You got me. Oh, well, because I'm a photographer not an artist. I don't know. We didn't say we were artists in graduate school.

AG: That made it easier?

AB: We were documentarians.

AG: You're still documenting.

AB: Yeah, actually. I'm documenting what's in my head. Showing my photographs to others is only telling part of the secret. For me photography was, and still is, a way of expressing myself, but without revealing exactly what I am thinking or what I'm trying to say. I'm not going to tell other people what to see in my work because I can't, but I do know that there are some pictures that they respond to. They may not know why they are responding, even how they're feeling, but certain images change something, throw them off a little bit. For me it is personal, and what other people take away is great.

NOTES

[1] Amy Blakemore, in Susan Sipple Elliott, *The South by Its Photographers* (Birmingham, AL: Birmingham Museum of Art, 1996), 20.

[2] Michelle White, "Amy Blakemore's Ephemeral Archives." *Gulf Coast Literary Magazine* 19, no. 1 (Winter 2007): 129–42.

[3] The photograph is of the sixty-seven-foot-tall Sam Houston Monument in Huntsville, Texas.

CHECKLIST OF THE EXHIBITION

All prints are courtesy of the artist and Inman Gallery, Houston.

1. *Three Girls*
1988
Gelatin silver photograph
15 x 15 inches (38.1 x 38.1 cm)

2. *Child*
1988
Gelatin silver photograph
15 x 15 inches (38.1 x 38.1 cm)

3. *Boy and Men*
1989
Gelatin silver photograph
15 x 15 inches (38.1 x 38.1 cm)

4. *Swing*
1992
Gelatin silver photograph
15 x 15 inches (38.1 x 38.1 cm)

5. *Cloistered Convent*
1992
Gelatin silver photograph
15 x 15 inches (38.1 x 38.1 cm)

6. *Plaster Marys*
1992
Gelatin silver photograph
15 x 15 inches (38.1 x 38.1 cm)

7. *Nurses*
1992
Gelatin silver photograph
15 x 15 inches (38.1 x 38.1 cm)

8. *Plaza*
1992
Gelatin silver photograph
15 x 15 inches (38.1 x 38.1 cm)

9. *Adam*
1991
Gelatin silver photograph
15 x 15 inches (38.1 x 38.1 cm)

10. *Steph*
1995
Chromogenic photograph
19 x 19 inches (48.3 x 48.3 cm)

11. *Apples*
1995
Chromogenic photograph
19 x 19 inches (48.3 x 48.3 cm)

12. *Harlow*
1998
Chromogenic photograph
19 x 19 inches (48.3 x 48.3 cm)

13. *Cod*
1995
Chromogenic photograph
19 x 19 inches (48.3 x 48.3 cm)

14. *Shoes*
1998
Chromogenic photograph
19 x 19 inches (48.3 x 48.3 cm)

15. *Sea*
1997
Chromogenic photograph
19 x 19 inches (48.3 x 48.3 cm)

16. *Pools*
1997
Chromogenic photograph
19 x 19 inches (48.3 x 48.3 cm)

17. *Signal Hill*
1997
Chromogenic photograph
19 x 19 inches (48.3 x 48.3 cm)

18. *Stormy Landscape*
1997
Chromogenic photograph
19 x 19 inches (48.3 x 48.3 cm)

19. *Robert's Window*
1997
Chromogenic photograph
19 x 19 inches (48.3 x 48.3 cm)

20. *Fairgrounds*
1997
Chromogenic photograph
19 x 19 inches (48.3 x 48.3 cm)

21. *Ladies' Room*
1997
Chromogenic photograph
19 x 19 inches (48.3 x 48.3 cm)

22. *Flag*
1999
Chromogenic photograph
19 x 19 inches (48.3 x 48.3 cm)

23. *Mary*
2008
Chromogenic photograph
19 x 19 inches (48.3 x 48.3 cm)

24. *Jim*
1999
Chromogenic photograph
19 x 19 inches (48.3 x 48.3 cm)

25. *Dad*
1999
Chromogenic photograph
19 x 19 inches (48.3 x 48.3 cm)

26. *Workshop*
1999
Chromogenic photograph
19 x 19 inches (48.3 x 48.3 cm)

27. *Cellar*
1999
Chromogenic photograph
19 x 19 inches (48.3 x 48.3 cm)

28. *Dog in Snow*
2004
Chromogenic photograph
19 x 19 inches (48.3 x 48.3 cm)

29. *Deer and Tepee*
2005
Chromogenic photograph
19 x 19 inches (48.3 x 48.3 cm)

30. *Little Garage*
2004
Chromogenic photograph
19 x 19 inches (48.3 x 48.3 cm)

31. *Boston Street*
2004
Chromogenic photograph
19 x 19 inches (48.3 x 48.3 cm)

32. *Airplane*
2005
Chromogenic photograph
19 x 19 inches (48.3 x 48.3 cm)

33. *Monument*
2005
Chromogenic photograph
19 x 19 inches (48.3 x 48.3 cm)

34. *Jill in Woods*
2005
Chromogenic photograph
19 x 19 inches (48.3 x 48.3 cm)

35. *Astoria*
1998/2008
Chromogenic photograph
19 x 19 inches (48.3 x 48.3 cm)

36. *Pam*
1997/2008
Chromogenic photograph
19 x 19 inches (48.3 x 48.3 cm)

BIOGRAPHY

AMY BLAKEMORE

Born Tulsa, Oklahoma, 1958
Lives and works in Houston, Texas

EDUCATION

1985
MFA in Photography,
The University of Texas, Austin, Texas

1982
BA in Art, Drury College,
Springfield, Missouri

1980
BS in Psychology, Drury College,
Springfield, Missouri

FELLOWSHIPS AND GRANTS

2004
Artist Grant, Artadia: The Fund for Art
and Dialogue, New York, New York

1997
Creative Artist Grants Award, The Cultural Arts
Council of Houston/Harris County, Texas

Creative Artist Grants Travel Award, Eleanor Freed
Foundation of the Cultural Arts Council of Houston/
Harris County, Texas

1992
Dozier Travel Grant, The Dallas Museum of Art,
Dallas, Texas

1989
Creative Artist Award, The Cultural Arts Council
of Houston, Houston, Texas

Houston Center for Photography Fellowship
Award, Houston, Texas

1987
Anne Giles Kimbrough Fund, Awards to Artists,
The Dallas Museum of Art, Dallas, Texas

1985–87
Core Fellow, The Core Program, The Glassell
School of Art, The Museum of Fine Arts, Houston,
Houston, Texas

EXHIBITIONS

SOLO EXHIBITIONS

2005

Amy Blakemore: Recent Pictures. Houston, Texas:
Inman Gallery, 25 February–2 April

Amy Blakemore. Pingyao, Taiyuan, Shanxi, P.R.
China: Pingyao International Photography Festival,
15–22 September

2002

Amy Blakemore: Photographs. Marfa, Texas:
The Marfa Book Company, March–April

Amy Blakemore Portraits. Houston, Texas:
Inman Gallery, 19 April–25 May

2001

Amy Blakemore: Pictures. Corpus Christi, Texas:
Gallery Four One One, 15 September–27 October

1999

Amy Blakemore: Ten Years. Houston, Texas:
Inman Gallery, 21 May–26 June.
Additional venue: Galveston, Texas:
The Galveston Arts Center, 17 July–22 August

Amy Blakemore. London, England:
Studio 9, 29 June–1 August

1996

FotoFest 96: Amy Blakemore, Recent Work.
Houston, Texas: Inman Gallery, 1–30 March

1995

Amy Blakemore "Story Pictures" and "Pilgrimage."
Kansas City, Missouri: Re-zone Gallery, Kansas
City Arts Institute

1984

Amy Blakemore. Austin, Texas:
Accent Photographic Gallery

SELECTED GROUP EXHIBITIONS

2008

Learning by Doing: 25 Years of the Core Program.
Houston, Texas: The Museum of Fine Arts,
Houston, 8 March–1 September

2007

Nexus/Texas. Houston, Texas: Contemporary Arts
Museum Houston, 17 August–21 October

Don't Mess with Texas. Ojai, California: Nathan
Larramendy Gallery, 27 October–30 November

2006

2006 Whitney Biennial: Day for Night. New York, New York: Whitney Museum of American Art, 2 March–28 May

Impossible Exchange: New Lens Based Work from Texas. Houston, Texas: Lawndale Art Center, 29 September–11 November

Silver. Houston, Texas: Houston Center for Photography, 3 November–17 December

2005

Through The Lens: A Sampling of Contemporary Photography in Texas. Arlington, Texas: Arlington Museum of Art, 16 April–25 June

Acquisitions of the Last Five Years: Texas Art Highlights. Houston, Texas: The Museum of Fine Arts, Houston, 3 June–9 October

Money, Baby! Artadia@DiverseWorks. Houston, Texas: DiverseWorks Art Space, 9 July–6 August

2004

S.E.L.E.C.T.I.V.E M.E.M.O.R.Y. San Antonio, Texas: The Bower, 2 April–22 May

2003

Inside Outside: Texas Women Photographers. Austin, Texas: Women and Their Work, 20 February–29 March.

Additional venues: Galveston, Texas: The Galveston Art Center; Houston, Texas: Houston Center for Photography; Abilene, Texas: The Grace Museum

Twenty Years of Graduate Photography: MFA Alumni 1982–2002. Austin, Texas: The University of Texas at Austin, 8–23 March

2002

Hard Core. Galveston, Texas: The Galveston Arts Center, 24 August–6 October

2001

A Love Affair with Pictures: 25 years of Collecting at the Museum of Fine Arts, Houston. Houston, Texas: The Museum of Fine Arts, Houston, 14 October– 30 December

2000

FotoFest 2000: Amy Blakemore, Todd Hido, Jane Hinton. Houston, Texas: Inman Gallery, 25 February–18 March

Click Chicks: Texas Women Photographers. Arlington, Texas: Arlington Museum of Art, 31 March–20 May. Additional venues: Denton, Texas: Texas Women's University; Dallas, Texas: Dallas Contemporary

People: Portraits by Texas Artists. Houston,
Texas: City Gallery at Wells Fargo Plaza,
21 August–20 October

Ten Year Anniversary Exhibition. Houston, Texas:
Inman Gallery, 8 September–6 October

1999
Krappy Kameras. New York, New York:
Soho Photo, 2–27 March

X.C.X.L: eXquisite Corpse eXtra Large.
Houston, Texas: Lawndale Art Center,
18 September–23 October

1998
Field of Vision: Five Gulf Coast Photographers.
Houston, Texas: Contemporary Arts Museum
Houston, 6 March–19 April

New Work: Gallery Artists. Houston, Texas:
Inman Gallery, 10 July–15 August

Jane Hinton/Amy Blakemore. Houston, Texas:
Inman Gallery, 27 February–20 March

1997
Flora Bella. Galveston, Texas: The Galveston Arts
Center, 26 April–1 June

*Retro-Photo III: Amy Blakemore, Skeet McAuley,
Bob Wade.* Dallas, Texas: Barry Whistler Gallery,
9–31 May

New Work: Gallery Artists. Houston, Texas:
Inman Gallery, 11 July–16 August

In Passing. Houston, Texas: Inman Gallery,
21 November 1997–3 January 1998

1996
Proof of Love. Houston, Texas: Lynn Goode Gallery,
2–17 February

*The Texas Collection of the Museum of Fine Arts,
Houston: Texas Modern and Post-Modern.* Houston,
Texas: The Museum of Fine Arts, Houston,
21 January–3 March

Photographs by Core Fellows, Past and Present.
Houston, Texas: The Glassell School of Art,
The Museum of Fine Arts, Houston,
29 February–17 March

The South by Its Photographers. Birmingham,
Alabama: Birmingham Museum of Art,
20 October–29 December. Additional venue:
Columbia, South Carolina: Columbia Museum
of Art, 24 January–6 April, 1997

Five Year Anniversary Exhibition. Houston, Texas:
Inman Gallery, 14 June–27 July

1995
Faith in Vision. Houston, Texas: Transco Tower
Gallery, 20 November–31 December

1994

Sons and Daughters: Invitational Alumni Exhibition.
Springfield, Missouri: Cox Gallery, Drury College,
18 February–9 March

Amy Blakemore and Jane Hinton. Houston, Texas:
Inman Gallery, 12 March–19 April

The Big Show. Houston, Texas: Lawndale Art
and Performance Center, 18 July–27 August

International Focus '94. Carmel, California: Center
for Photographic Art, 11 November–16 December

1993

*Re:Framing the Past, Recent Work from Texas
Women Photographers.* Austin, Texas: Women
and Their Work, 1 July–1 August

Stairway to Heaven. Galveston, Texas: The Galveston
Arts Center, 17 July–29 August. Additional venue:
Denton, Texas: Texas Women's University

*Texas Focus: Recent Acquisitions From
The Mundy and Willour Collections.* Houston,
Texas: The Museum of Fine Arts, Houston,
5 September–21 November

1992

Childhood: Photographs of Children. Houston,
Texas: Benteler Morgan Gallery

1991

U.S. Biennial 4, Past Purchase. Norman, Oklahoma:
The University of Oklahoma, Fred Jones Jr.
Museum of Art, 9 July–8 September

Six Texas Artists. Lafayette, Louisiana: Artists' Alliance

1990

Recent Acquisitions: Houston Photographers.
Houston, Texas: The Museum of Fine Arts,
Houston, 3 February–29 April

Reinventing Reality: Five Texas Photographers.
Houston, Texas: Blaffer Gallery, The University
of Houston, 17 February–1 April

*TFAA (Texas Fine Arts Association) New American
Talent: The 6th Exhibition.* Austin, Texas: Austin
Museum of Art, 7 May–3 June

Fellowship Exhibition. Houston, Texas: Houston
Center for Photography, 29 June–29 July

1989

An Exhibition in Mixed Media. Springfield, Missouri:
Cox Gallery, Drury College

1988

TFAA New American Talent: The 4th Exhibition.
Austin, Texas: Austin Museum of Art,
7 May–21 June

Houston Area Exhibition. Houston, Texas:
Blaffer Gallery, The University of Houston,
3 September–23 October

1987
Annual Core Fellows Exhibition. Houston, Texas:
The Glassell School of Art, The Museum of Fine
Arts, Houston, 18 March–5 April

TFAA New American Talent 1987. Austin, Texas:
Austin Museum of Art, 2 May–21 June

1986
Annual Core Fellows Exhibition. Houston, Texas:
The Glassell School of Art, The Museum of Fine
Arts, Houston, 3 April–27 April

1985
TFAA New American Talent 1985. Austin, Texas:
Austin Museum of Art, 13 April–26 May

M.F.A. Thesis & Student Exhibition. Austin, Texas:
Archer M. Huntington Art Gallery, The University
of Texas at Austin, 2–26 May

Photo/Flo. Arlington, Texas: The University
of Texas at Arlington

1984
U.S. Biennial 2. Norman, Oklahoma:
The University of Oklahoma, Fred Jones Jr.
Museum of Art, 1 April–11 May

M.F.A. Thesis & Student Exhibition. Austin, Texas:
Archer M. Huntington Art Gallery, The University
of Texas at Austin, 15 April–13 May

PhotoSpiva. Joplin, Michigan: Spiva Art Center,
4–29 November

Southern Biennial 2. Hammond, Louisiana:
Southwestern Louisiana University

Salt and Pepper. East Lansing, Michigan:
Kresge Art Center, Michigan State University

Women Envision: Texas Artist Tour. Austin, Texas:
St. Edward's University

Texas Women Photographers.
Amsterdam, The Netherlands: Cannon Gallery

Selected Portfolios. Austin, Texas:
Texas Photographic Society

1983
Three Person Exhibition. Springfield, Missouri:
Cox Gallery

1980
PhotoSpiva. Joplin, Michigan: Spiva Art Center,
2–30 November

BIBLIOGRAPHY

CATALOGUES AND OTHER PUBLICATIONS

2006

Iles, Chrissie, and Philippe Vergne, eds., *Whitney Biennial 2006: Day for Night.* New York: Whitney Museum of American Art and Harry N. Abrams, 2006.

2005

Cruz, Amanda. *Artadia Houston 2004.* New York: Artadia: The Fund for Art and Dialogue, 2005.

2000

Greene, Alison de Lima. *Texas: 150 Works from the Museum of Fine Arts, Houston.* Houston: The Museum of Fine Arts, Houston; New York: Harry N. Abrams, 2000.

1999

Tucker, Anne Wilkes, and Susie Kalil. *Amy Blakemore: Ten Years.* Houston, Texas: Inman Gallery, 1999.

1998

Irvine, Alexandra L. *Field of Vision: Five Gulf Coast Photographers.* Houston: Contemporary Arts Museum Houston, 1998.

1996

Elliot, Susan Sipple. *The South by Its Photographers.* Birmingham: Birmingham Museum of Art, 1996.

1993

Greene, Alison de Lima. *Stairway to Heaven.* Galveston: The Galveston Arts Center, 1993.

1990

Ward, Elizabeth. *Reinventing Reality: Five Texas Photographers.* Houston: University of Houston, 1990.

ARTICLES

2008

Britt, Douglas. "The Flypaper Effect: MFAH Artist's Residency Has Lured New Talent to Houston for 25 Years." *The Houston Chronicle,* December 19, 2008, Zest 10–13.

2007

Klaasmeyer, Kelly. "Career Cred." *Houston Press,* February 8, 2007, 38.

Schulze, Troy. "State of the Art." *Houston Press,* September, 2007, 46.

White, Michelle. "Amy Blakemore's Ephemeral Archives." *Gulf Coast Literary Magazine* 19, no. 1 (Winter 2007): 129–42.

2006

Kimmelman, Michael. "Biennial 2006: Short on Pretty, Long on Collaboration." *The New York Times,* March 3, 2006, B29.

Sengara, Lorissa. "Whitney Biennial 2006." *Canadian Art* 23, pt. 2 (Summer 2006): 82–84.

White, Roger. "2006 Whitney Biennial." *Artlies* 50 (Spring 2006): 119–20.

2005

Klaasmeyer, Kelly. "Pictures of Someone." *Houston Press,* March 10–18, 2005, 36.

2003

Ali, Atteqa. "Inside Outside: Texas Women Photographers." *Artlies* 38 (Spring 2003): 68–69.

2002

McBride, Elizabeth. "Amy Blakemore: Photographs." *Artlies* 34 (Spring 2002): cover, 75.

Devine, John. "Fugitive Moments." *Houston Press,* May 23–29, 2002, 56.

Johnson, Patricia C. "New works break away from the past." *Houston Chronicle,* May 23, 2002, 3.

Schwabsky, Barry. "Amy Blakemore at Inman Gallery." *Artforum* 41, no. 2 (October 2002): 158–59.

2000

Anspon, Catherine. "10 Year Anniversary Exhibition." *Artlies* 28 (Fall 2000): 102–3.

Anspon, Catherine. "Ready for their Close-ups." *Paper City* (March 2000): 30.

Colpitt, Frances. "Space City Takes Off." *Art in America* 88, no. 10 (October 2000): 68, 75.

Frohman, Mark. "Insecurity Complex." *Houston Press,* March 16, 2000.

McCormick, Carlo. "Houston Journal." *Artnet* (May 26, 2000).

1999

Davenport, Bill. "Photographs of Isolation: Amy Blakemore." *SPOT, The Houston Center for Photography* (Fall 1999): 18.

Dewan, Shaila. "The World Made Visible." *Houston Press,* June 17–23, 1999, 55.

COPYRIGHT AND PHOTOGRAPHY CREDITS

In grateful acknowledgment of all of the friends who have added the following works by Amy Blakemore to the permanent collection of the Museum of Fine Arts, Houston:

Three Girls, 1988
Gelatin silver photograph, 20 x 23 ⅞ inches
(50.8 x 60.8 cm), museum purchase with
funds provided by Clinton T. Willour in honor
of Mathilda Cochran, 89.119.

Untitled, 1992
Gelatin silver photo-postcard, 6 x 5 inches
(15.2 x 12.7 cm), gift of the artist, 92.443.

Plaza, 1992
Selenium-toned gelatin silver photograph, printed
1993, 17 ⅞ x 15 ⅞ inches (45.4 x 40.5 cm),
museum purchase with funds provided by Clinton
T. Willour in honor of Mark Petr, 93.272.

Apples, 1995
Chromogenic photograph, 23 ⅞ x 20 inches
(60.8 x 50.8 cm), museum purchase with funds
provided by Clinton T. Willour in memory of
Norma Ory, 96.808.

Boy and Ball, 1994
Toned gelatin silver photograph, 14 x 10 ⅞ inches
(35.6 x 27.8 cm), gift of the Board of Directors,
Artist Advisory Board, and Staff of DiverseWorks
1996–1997, and the artist in memory of Chris
Kalil, 96.1004.

Two Chairs, 1999
Chromogenic photograph, 19 ⅞ x 24 inches
(50.6 x 61 cm), gift of the artist, Inman Gallery,
and MFAH staff in memory of Sandy Kane's son,
Rusty Keithline, 99.206.

Harlow, 1998
Chromogenic photograph, 24 x 20 inches
(61 x 50.8 cm), gift of Clinton T. Willour
in honor of Anne Wilkes Tucker, 99.405.

Mom, 2000
Chromogenic photograph, 19 ⅞ x 23 ⅞ inches
(50.6 x 60.8 cm), gift of the artist and Inman
Gallery in honor of Lana McBride, 2000.170.

Child, 1988
Gelatin silver photograph, printed 2002,
14 ⅞ x 10 ⅞ inches (37.9 x 27.8 cm),
museum purchase with funds provided
by Mrs. Clare A. Glassell, 2001.271.

Dog in Snow, 2003
Chromogenic photograph, printed 2005,
20 x 24 inches (50.8 x 61 cm), gift
of Christopher Edwin Vroom in honor of
Alison de Lima Greene, 2005.237.

Dad, 1999
Chromogenic photograph, printed 2005,
20 x 24 inches (50.8 x 61 cm), gift
of Christopher Edwin Vroom in honor of
Alison de Lima Greene, 2005.238.

Workshop, 1999
Chromogenic photograph, printed 2005,
20 x 24 inches (50.8 x 61 cm), gift
of Christopher Edwin Vroom in honor of
Alison de Lima Greene, 2005.239.

Jude, 2004
Chromogenic photograph, 20 x 24 inches
(50.8 x 61 cm), gift of Steven J. Snook in
honor of Clinton T. Willour, 2005.379.

JK, 2007
Chromogenic photograph, 20 x 21 ¼ inches
(50.8 x 54 cm), gift of Frances and Peter C.
Marzio, 2007.1593.

Girl & Game, 1990
Gelatin silver photograph, 13 ⅞ x 10 ⅞ inches
(35.4 x 27.6 cm), gift of Will Michels in memory
of John Cleary and his lifelong love of photographs,
2008.120.

Stormy Landscape, 1997
Chromogenic photograph, 19 ⅞ x 24 inches
(50.6 x 61 cm), gift of Will Michels in honor of
Justin Furstenfeld and the birth of his daughter
Blue Reed Furstenfeld, 2008.209.